C000132875

BERLIN
architecture & design

Edited and written by Chris van Uffelen
Concept by Martin Nicholas Kunz & Dr. Silvia Kienberger

teNeues

Content

introduction

Band des Bundes
1993-1994
Axel Schultes, Charlotte Frank,
Christoph Witt

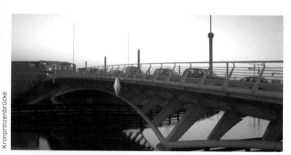

Kronprinzenbrücke

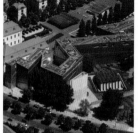

Jüdisches Museum

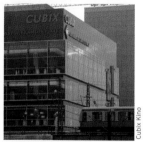

Cubix Kino

Die immensen Bauvorhaben nach Mauerfall (1989), Wiedervereinigung (1990) und Umzug der Regierung (1999) führten zu vielen, oft polemisch geführten Debatten über den Umgang mit Architektur: Neubau oder Rekonstruktion? Historisierend oder modern? Die Lösungen sind so vielfältig wie der Kreis der Architekten universell ist. Dieses Buch stellt aktuelle Interior Design Trends und herausragende architektonische Solitäre Berlins vor und gibt u. a. anhand von Beispielen aus den Bereichen des Wohnbaus, der Regierungsgebäude oder des Laden-, Hotel- und Bardesigns einen Überblick über die Entwicklungen in den letzten fünfzehn Jahren.

The building boom in Berlin since the Wall fell (1989), the country was reunified (1990) and the government relocated to the city (1999) has led to heated debates concerning architecture. Should one build anew or reconstruct? In an historical or modern style? The solutions are as diverse as the circle of architects is. This book presents interior design trends and exceptional architecture in Berlin, thereby providing a survey of new residential and government buildings, stores, hotels and bars from the past fifteen years.

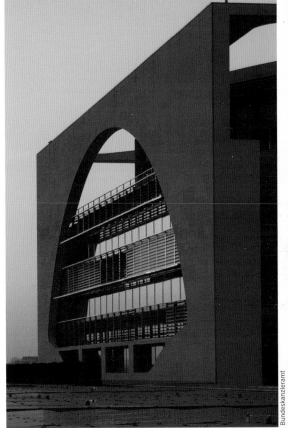

Bundeskanzleramt

7

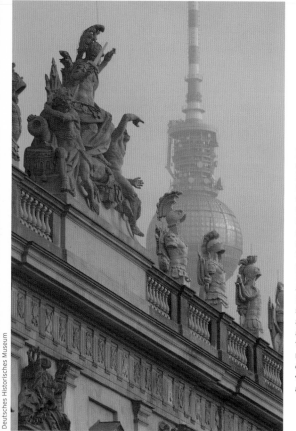

La multitude des projets de construction après la chute du Mur (1989), la Réunification (1990) et l'installation du gouvernement à Berlin (1999) a suscité de nombreux débats, souvent polémiques, sur le rapport à l'architecture. Nouvelles constructions ou reconstruction ? Historisme ou modernisme ? La diversité des solutions est à l'image de l'universalité des architectes. Ce livre présente les tendances actuelles du design d'intérieur, des réalisations architecturales remarquables et, à l'exemple d'immeubles d'habitation, de bâtiments gouvernementaux ou de boutiques, hôtels et bars, donne un aperçu de l'évolution des quinze dernières années à Berlin.

Stadtschloss

Johann Arnold Nering, Andreas Schlüter,
Johann Friedrich Eosander (Reconstruction)
Förderverein Berliner Schloss e.V.
Original building 15. - 18. Century

www.berliner-schloss.de

Los inmensos proyectos arqui-
tectónicos tras la caída del Muro
(1989), la Reunificación (1990) y
la mudanza del Gobierno (1999)
llevaron a demasiados debates
a menudo polémicos sobre el
trato con la arquitectura: ¿Edifi-
cio nuevo o reconstrucción?
¿Historicista o moderno? Las
soluciones son tan variadas co-
mo universal es el círculo de los
arquitectos. Este libro presenta
tendencias actuales del diseño
de interiores y excelentes joyas
arquitectónicas de Berlín y ofre-
ce, entre otros, mediante ejem-
plos en las áreas de la
construcción de viviendas, de
edificios gubernamentales o del
diseño de tiendas, hoteles y ba-
res, una visión de conjunto acer-
ca de la evolución en los últimos
quince años.

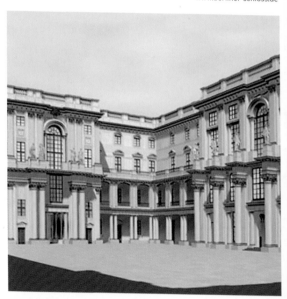

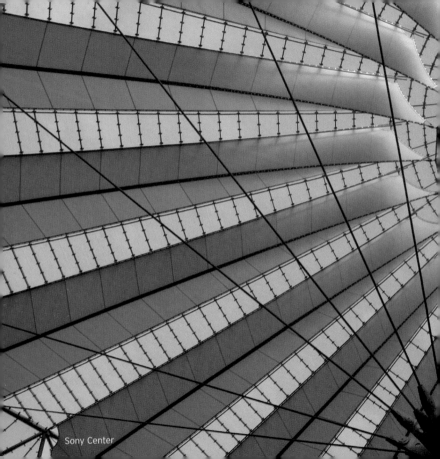
Sony Center

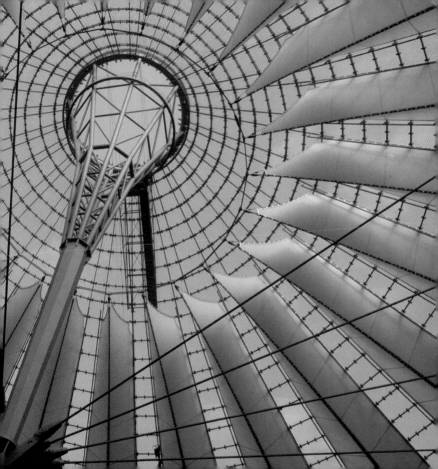

to see . living
office
culture + education
public

 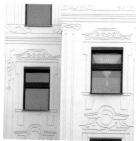

 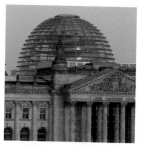 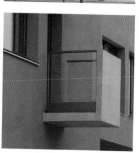

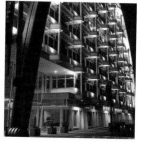

Belziger Straße 23
Reconstruction

Andreas Hild & Tillmann Kaltwasser

1999
Belzigerstraße 23
Schöneberg

www.hildundk.de

In der Diskussion um zeitgenössische Architektur in historischem Kontext bietet dieser Bau eine der originellsten Lösungen: Die Fassadengliederung des Vorgängerbaus wurde mit Schablonen in den Putz eingetieft, sodass sich der Bau eigenständig aber harmonisch in den gründerzeitlichen Kontext fügt.

This building offers an original solution to the problem of integrating contemporary architecture into historical contexts—the structure of the older building was pressed into the wet plaster of the new building's facade. It can stand alone, yet harmonizes with its surroundings.

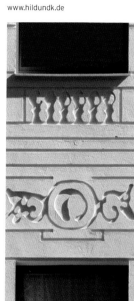

Ce bâtiment propose l'une des solutions les plus originales dans la discussion sur l'architecture contemporaine dans le contexte historique : l'articulation de la façade initiale est reproduite en creux dans l'enduit, de sorte que l'immeuble s'intègre individuellement mais aussi harmonieusement dans le cadre ancien.

Esta edificación constituye una de las soluciones más originales en la discusión acerca de la arquitectura contemporánea en un contexto histórico: La estructura de la fachada del edificio precedente se insertó en el revoque por medio de plantillas, de manera que el edificio fue ensamblado al contexto del período de la Gründerzeit de modo independiente pero harmonioso.

Bundesschlange
Parliamentarians' Apartments

Georg Bumiller (Masterplan)
Jörg Pampe & Irene Keil (Superstructural Section)
Urs Müller, Thomas Rhode & Jörg Wandert
(Atrium Housing Blocks)
Dieter Alfred Kienast, Günther Vogt & Partner
(Landscape)

1997-1999
Moabiter Werder
Tiergarten

Um den preiswerten Berliner Wohnungsmarkt stabil zu halten, war es eine Bedingung für den Regierungsumzug, Wohnungen für die zuziehenden Bonner Angestellten zu schaffen. Inzwischen sind aber auch Berliner in den sich in Anlehnung an den Verlauf der Spree windenden Zeilenbau am Ende des „Band des Bundes" gezogen.

To ensure that rents in Berlin remained stable, housing had to be constructed for the civil servants expected to relocate from Bonn before the government moved to the city. In the meantime Berliners have also moved into the building that winds along the River Spree.

Afin de garantir la modicité des prix du logement à Berlin, le déménagement du gouvernement impliquait la création de logements pour les employés venus de Bonn. Entre-temps ces immeubles parallèles longeant le cours de la Spree à l'extrémité du complexe gouvernemental accueillent également des Berlinois.

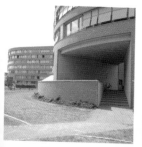

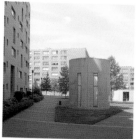

Una condición para la mudanza del gobierno, con el fin de mantener estable el barato mercado inmobiliario berlinés, fue la de crear viviendas para los empleados de Bonn que se trasladaban. Pero, entretanto, también se han mudado los berlineses a los edificios en línea situados al final del "Cordón del Estado Federal" que serpentean siguiendo el curso del Spree.

Ludwig-Erhard-Haus

Nicholas Grimshaw & Partners
Mark Whitby & Bird (Structural Engineering)

1991-1999
Fasanenstraße 85
Charlottenburg

www.leh-berlin.de
www.grimshaw-architects.com
www.whitbybird.com

Wie das Pariser Centre Pompidou besteht der Bau aus aufgereihten tragenden Elementen – dort Tore, hier Beton-Parabelbögen – sowie eingehängten Ebenen. An der Fasanenstraße treten die Ebenen noch vor die Bögen und bilden die baupolitisch gewünschte geschlossene Blockfront mit sichtbarer Traufhöhe.

Like the Centre Pompidou in Paris, this building consists of a series of constructive elements—big doorways and concrete arches—as well as suspended floors. The extension of floors beyond the arches on Fasanenstraße helps the building conform to code.

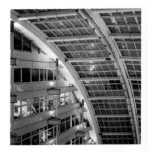

Comme le Centre Pompidou à Paris cette construction se compose d'éléments porteurs alignés – ici des arcs paraboliques en béton – et de niveaux suspendus. Du côté de la Fasanenstraße les niveaux se prolongent au-delà des arcs en un front fermé souhaité par les services de l'urbanisme avec hauteur de corniche visible.

Como el Centre Pompidou en París, la construcción consta de elementos de soporte colocados en hileras –allí puertas, aquí arcos paralelos de hormigón– así como de niveles enquiciados. En la Fasanenstraße los niveles incluso sobresalen de los arcos constituyendo la fachada compacta con altura visible que la política urbanística deseaba.

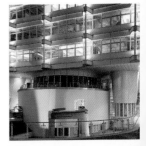

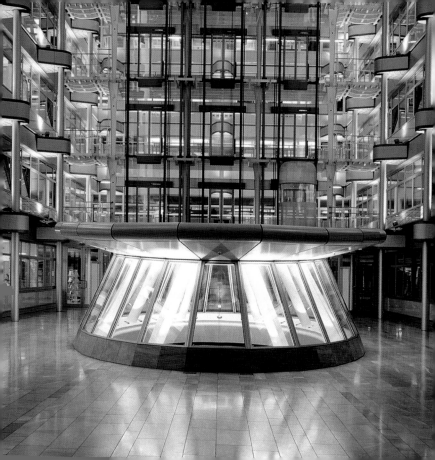

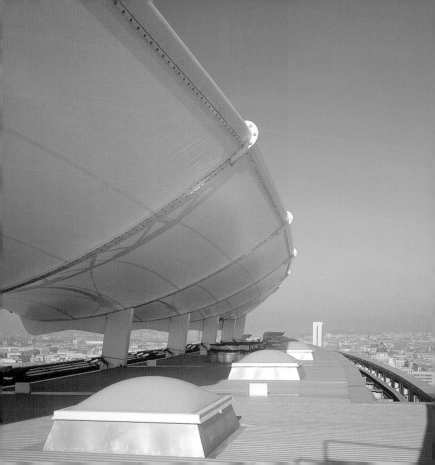

GSW-Hauptverwaltung
Headquarter

1995-1998
Kochstraße 22
Kreuzberg

www.gsw.de
www.sauerbruchhutton.de
www.arup.com

Matthias Sauerbruch, Louisa Hutton Architekten
Ove Arup (Structural Engineering)

Drei neue Bauteile umgeben das alte Hochhaus und lenken die Blicke auf sich: eine geschwungene schwarze Zeile an der Kochstraße trägt ein ovales Bauelement mit Wellblechfassade in kühlen sowie eine geschwungene Hochhausscheibe mit Flugdach in warmen Farben.

Three new building segments surround the old high-rise and attract our attention: a long, winding black low-rise building on the Kochstraße supports an oval building segment faced with corrugated steel in cool colors and a curving high-rise tower with a suspended roof in warm colors.

Trois nouveaux éléments encadrent l'ancienne tour et lui volent la vedette : un immeuble noir incurvé bordant la Kochstraße supporte une partie de bâtiment ovale avec une façade en tôle ondulée aux teintes froides ainsi qu'une tour incurvée aux teintes chaudes surmontée d'un toit monopente.

Tres nuevas piezas arquitectónicas rodean el antiguo bloque de pisos y atraen las miradas hacia ellas: En la Kochstraße, una negra hilera curvada de edificios sustenta un elemento oval con fachada de chapa ondulada en colores fríos así como un edificio alto con planta en forma de disco curvado y tejado de vuelo en colores cálidos.

Auswärtiges Amt
Foreign Office

Thomas Müller, Ivan Reimann (Architecture)
Hans F. Kollhoff, Helge Timmermann (Original Building, Reconstruction)
Dieter A. Kienast, Günther Vogt & Partner (Landscape)
Heinrich Wolff (Original Building "Reichsbank")

1996-1999
Werderscher Markt 1
Mitte

www.auswaertiges-amt.de
www.mueller-reimann.de

Der Neubau übernimmt vom hermetisch geschlossenen Altbau die Grundelemente Gebäuderiegel und Hof, ordnet sie jedoch zu einem offenen Baukörper an. An der Marktseite ist durch die Verglasung Karl Friedrich Schinkels Kirche sichtbar – und bald wohl auch eine Rekonstruktion seiner Bauakademie.

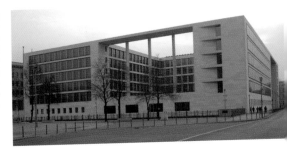

The new building took over the characteristic layout of older buildings with a segment facing the street and an enclosed courtyard behind, but used them to create an open structure. Through the glass facade that faces the market, there is a view of the church designed by Karl Friedrich Schinkel—and soon also one of his reconstructed Academy of Architecture.

Le nouveau bâtiment reprend, en les agençant en une structure ouverte, les éléments fondamentaux de la barre initiale et de la cour. Côté Werderscher Markt la façade ouest vitrée permet d'apercevoir l'église conçue par Karl Friedrich Schinkel – et bientôt la reconstruction de son académie d'architecture.

El edificio nuevo toma los travesaños y el patio como elementos básicos de la antigua edificación, que aparecía herméticamente compacta y, en cambio, los ordena en una edificación abierta. Por el lado del mercado puede verse, gracias a la cristalera, la iglesia de Karl Friedrich Schinkel y pronto también una reconstrucción de su academia de arquitectura.

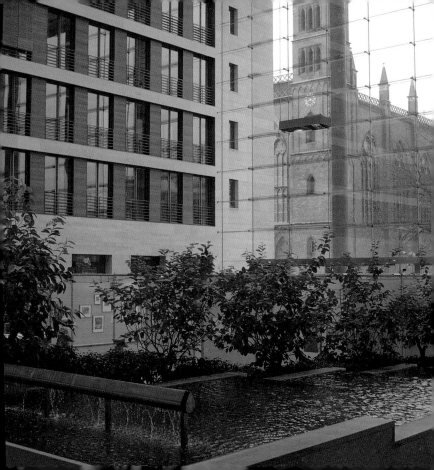

Landesvertretungen
Federal States' Office Buildings

Baden-Württemberg: 07

1998-2000
Tiergartenstraße 15
Tiergarten
Dietrich Bangert

www.baden-wuerttemberg.de

Nordrhein-Westfalen: 06

2000-2001
Hiroshimastraße 12-16
Tiergarten
Karl-Heinz Petzinka, Thomas Pink
+ Partner

www.bund-nrw.de
www.petzinka-pink.de

24

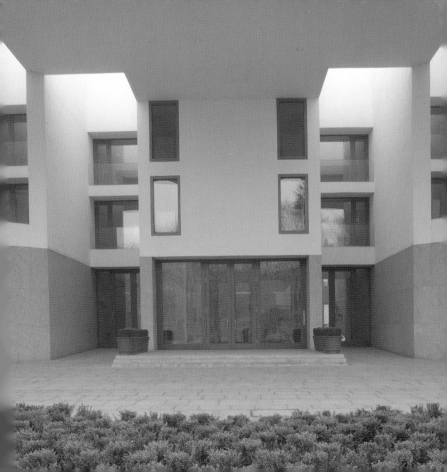

Schleswig-Holstein &
Niedersachsen: 08

1999-2001
Allee in den Ministergärten
Tiergarten
Ingeborg Lindner-Böge /
Jürgen Böge
Birgit Cornelsen-Seelinger /
Caspar Seelinger
Martin Seelinger + Maximilian Vogels

www.cornelsen-seelinger.com

Die Gebäude weisen den Stil der „Neuen Einfachheit" auf, wobei die Oberflächengestaltung wie im Falle der Vertretung von Brandenburg oder eine konstruktive Idee wie bei der Hessischen Repräsentanz das Erscheinen des Außenbaus dominieren. Die Ministergärten waren seit 1871 Zentrum deutscher Politik. Städtebaulicher Entwurf (1993–1994): Hildebrand Machleidt.

Les édifices sont conçus dans le style de la « Nouvelle Simplicité ». Leur aspect extérieur est déterminé par le matériau utilisé (représentation du Brandebourg) ou par l'architecture (représentation de la Hesse). A partir de 1871 ce quartier fut le cœur politique de l'Allemagne. Concept urbanistique (1993–1994): Hildebrand Machleidt.

Saarland: 09

1999-2001
Allee in den Ministergärten
Tiergarten
Peter Alt & Thomas Britz

www.landesvertretung.saarland.de
www.thomasbritz.de

Hessen: 10

1999-2002
Allee in den Ministergärten
Tiergarten
Michael Christl &
Joachim Bruchhäuser

www.hessen.de
www.christl-bruchhaeuser.de

The buildings illustrate New Simplicity. The exteriors are dominated by single elements, like the facade—the Representation of Brandenburg—or a structural idea—the Representation of Hesse. The New Chancellery stood here until 1945. The "Ministers' Gardens" have been a center of German politics since 1871.
Urban planning (1993–1994): Hildebrand Machleidt.

Los edificios muestran el estilo de la "Nueva Sencillez" y eso que la configuración de la superficie, como en el caso de la Representación de Brandeburgo, o una idea constructiva, como en la Representación de Hesse, dominan la apariencia de la construcción exterior. Los Jardines Ministeriales fueron desde 1871 el centro de la política alemana.
Proyecto urbanístico (1993–1994): Hildebrand Machleidt.

Brandenburg & Mecklenburg-Vorpommern: 11

1999-2001
Allee in den Ministergärten
Tiergarten
gmp - von Gerkan, Marg und Partner

www.gmp-architekten.de

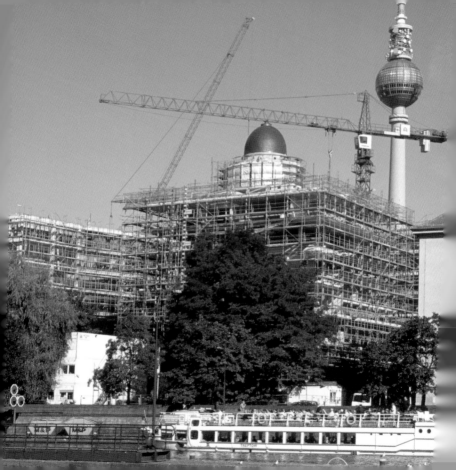

Niederländische Botschaft
Dutch Embassy

2000-2002
Klosterstraße / Rolandufer
Mitte

www.dutchembassy.de
www.oma.nl

Office for Metropolitan Architecture (OMA),
Rem Koolhaas

Die Struktur des Baus greift die typische Berliner Blockbebauung auf, wie sie der Nachbarbau zeigt, konterkariert diese aber durch das Aufbrechen der Bauvolumen und der Betonung der geschossübergreifenden Erschließung.

The structure of the building echoes the characteristic manner of building in closed blocks typical of Berlin and exhibited by the adjacent buildings. At the same time it repudiates it through its open structure which emphasizes the access ways from one floor to the next.

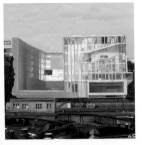

La structure du bâtiment reprend la forme typiquement berlinoise de l'îlot, celle de l'immeuble voisin, tout en la contrecarrant en rompant le volume du bâti et en soulignant les circulations englobant plusieurs niveaux.

La estructura de la edificación retoma la típica construcción berlinesa en bloques, como la que muestra el edificio vecino, pero la desbarata rompiendo con el volumen de construcción y con el énfasis en el aprovechamiento general de varias plantas.

29

DZ-Bank

Frank Owen Gehry and Associates (Architecture)
Jörg Schlaich, Rudolf Bergermann & Partner (Structural Engineering)

1996-1999
Pariser Platz 3
Mitte

www.dzbank.de
www.frank-gehry.com
www.sbp.de

Aufgrund der strikten Platzver-ordnung musste Gehry das freie Formenspiel ins Innere verlegen: Im Atrium, dessen Umbauung ebenso streng ist wie der Außenbau, liegt der Konferenz-raum als autarkes amorphes Gebilde und wirkt zwischen den streng gegliederten Hoffassaden umso rätselhafter.

The strict regulations on build-ings on Potsdamer Platz forced Gehry to save his typical free-flowing forms for inside. In the atrium, formed by building ele-ments as severe as the exterior, there is a conference room as an amorphous entity. It seems quite cryptic surrounded by austere facades.

La rigueur des contraintes relati-ves au site obligea Gehry à loca-liser à l'intérieur le libre jeu des formes. Dans l'atrium, entouré de formes architecturales aussi sévères que celles de l'extérieur, la salle de conférences apparaît d'autant plus énigmatique de-vant la stricte articulation des fa-çades de la cour.

Debido a la estricta ordenación de la plaza, Gehry tuvo que trasladar el libre juego de for-mas al interior: En el atrio, cuyo volumen de edificación es tan sobrio como en el exterior, está la sala de conferencias como una estructura amorfa y autár-quica que produce un efecto aún más enigmático ante la estricta estructuradas de las fa-chadas del patio.

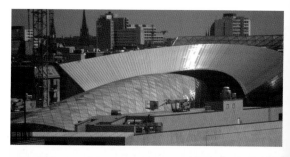

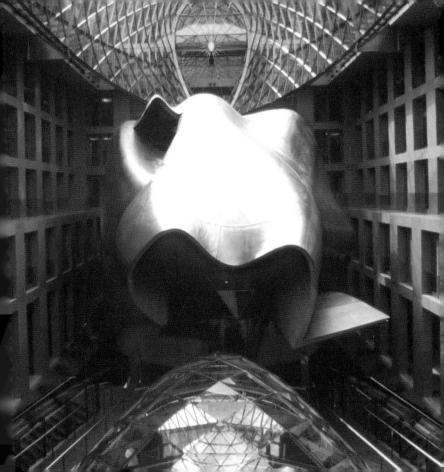

Französische Botschaft
French Embassy

Christian U. de Portzamparc,
Steffen Lehmann

1997-2003
Pariser Platz 5
Mitte

www.botschaft-frankreich.de
www.chdeportzamparc.com

Der dreizonige Fassadenaufbau zitiert den Vorgängerbau von vor 1945, doch behauptet sich das zeitgenössische Bauen mit schrägen Laibungen und asymmetrischen Fensterflächen. Der Bau setzt sich damit über die Bauvorgaben für den Pariser Platz – geschlossene Platzwände und „Lochfassaden" – hinweg.

The trizonal facade cites the building that occupied the site before the war, but this building has asymmetrical windows with slanted jambs. The specifications for the Pariser Platz requiring regularly punctuated stone facades were ignored.

L'agencement de la façade en trois couches se réfère à la construction d'avant 1945 tout en affirmant son caractère contemporain avec ses embrasements obliques et les bandeaux asymétriques des fenêtres. Son architecture s'affranchit ainsi des exigences énoncées pour la Pariser Platz : murs falaises et « façades ajourées ».

La construcción de la fachada a tres zonas remite al edificio precedente anterior a 1945, pero la edificación contemporánea se afirma con intradós oblicuos y ventanales asimétricos. Con ell, la construcción pasa por alto los requisitos para la edificación de la Pariser Platz: paredes compactas hacia la plaza y "fachadas punteadas".

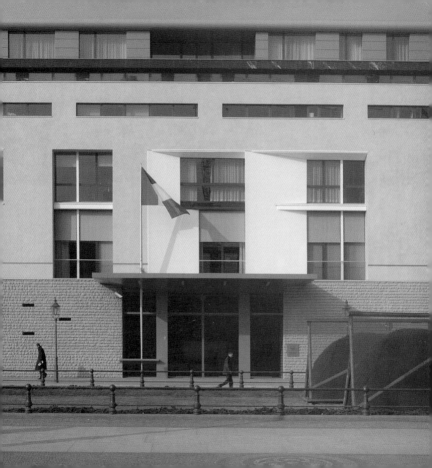

Bundestag im Reichstag
Parliament

Norman Foster & Partners (Architecture)
Paul Baumgarten (Reconstruction 1957–1961)
Paul Wallot (Original Building 1884–1894)

1994-1999
Platz der Republik
Mitte

www.bundestag.de
www.fosterandpartners.com

Während noch über die Frage Rekonstruktion oder Neuformulierung gestritten wurde, gewann Foster den Wettbewerb mit einem Projekt ohne Kuppel, das den Altbau vitrinenartig überdacht hätte. Später wurde doch eine Kuppel gewünscht. Ihre transparente Struktur ist begehbar und Klimaanlage sowie Lichtquelle zugleich.

The debate on reconstruction or reformulation was still raging, when Sir Norman Foster's design won the competition. The vitrine-like roof he foresaw was abandoned in favor of a glass dome that visitors can enter. It provides temperature regulation and light.

En pleine discussion sur la question de la reconstruction ou de la reformulation, Foster remportait le concours avec un projet sans coupole coiffant le bâtiment ancien comme une vitrine. Par la suite une décision privilégiant la coupole l'emporta. Sa structure transparente, source de lumière et climatisation à la fois, se visite

Mientras todavía se discutía el tema de la reconstrucción o la redefinición, Foster ganó el concurso con un proyecto sin cúpula que debía techar el edificio antiguo al modo de una vitrina. Pero más tarde se decidió a favor de una cúpula. Se puede caminar por su estructura transparente la cual constituye, al mismo tiempo, aire acondicionado y fuente de luz.

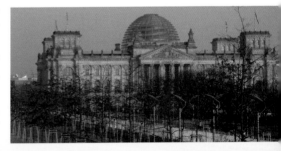

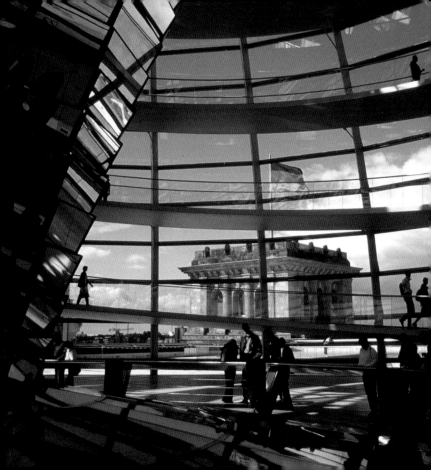

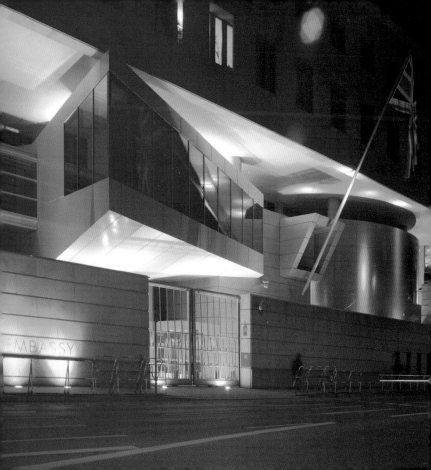

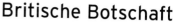

Britische Botschaft
British Embassy

1996-2000
Wilhelmstraße 70-71
Mitte

www.britischebotschaft.de
www.wilford.de
www.whitbybird.com

Michael Wilford, Manuel Schupp (Architecture)
Mark Whitby & Bird (Structural Engineering)

Die stadtplanerisch gewünschte „steinerne Lochfassade mit traufständigem Dach" wird im ersten Obergeschoss durch metallene Großformen aufgerissen, die auf das verspielte Innere vorbereiten. Vom Innenhof gelangt man über eine Monumentaltreppe in einen hellen zweiten „Hof", einen großen Ein-Stützensaal.

The punctured stone façade has a roof rising up over a gutter at the same height as those of the neighboring buildings, as stipulated by city planners. Gaps on the first-floor level reveal large metal structures that prepare us for the innovative interior. In the inner courtyard a broad flight of stairs leads to a bright, second "courtyard" in the form of a large hall supported by a single pillar.

La façade de pierre avec sa hauteur de corniche constante, exigée par les urbanistes, est rompue au niveau du premier étage par de grandes formes métalliques annonçant l'originalité de l'agencement intérieur. Depuis la cour intérieure on accède par un escalier monumental à une salle à pilier unique formant une seconde cour.

La "fachada punteada de piedra con canalón hacia la calle" –urbanísticamente deseada– se rompe en el primer piso mediante grandes moldes de metal que preparan un interior alegre. Por una monumental escalinata se llega, desde el patio interior, a un segundo "patio" luminoso, una gran sala con un pilar.

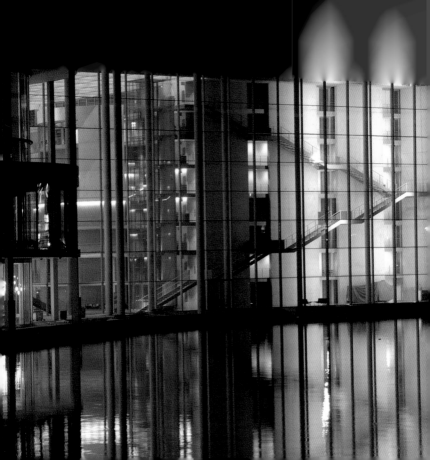

1996-2000 / 1997-2004
Dorotheenstraße, Reichstagufer,
Wilhelmstraße,
Ebertstraße / Spreebogen,
Paul-Löbe-Allee, Schiffbauerdamm
Mitte / Tiergarten

www.parlament-berlin.de
www.busmann-haberer.de
www.cie.nl
www.gmp-architekten.de
www.asp-architekten.de
www.vandenvalentyn.de
www.braunfels-architekten.de

Abgeordnetenbauten
Parliamentarians' Offices

Busmann & Haberer, De Architekten Cie.,
gmp – von Gerkan, Marg & Partner, Schweger & Partner,
Thomas van den Valentyn / Stephan Braunfels

Die Dorotheenblöcke mit ihrer historischen Bausubstanz sollten von unterschiedlichen Architekten gebaut werden, um als gewachsene Struktur zu erscheinen. Die beiden Bauten im „Band des Bundes" hingegen bilden programmatisch „neue" Großstrukturen innerhalb des Gesamtkomplexes.

Il était prévu de confier la réalisation des îlots de la Dorotheenstraße, avec leur bâti historique, à différents architectes pour ainsi obtenir une structure graduelle. Les deux édifices du « Ruban de la Fédération » s'inscrivent par contre dans les « nouvelles » grandes structures au sein du complexe global.

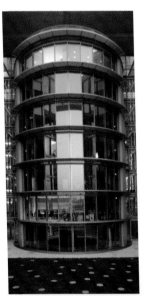

The intention in having the "Dorotheenblöcke" planned by different architects was to ensure that the building structure maintained the appearance of having developed organically. While the two buildings in the "band of federal building", by contrast, programmatically represent "new" large structures within the overall complex.

Los bloques en Dorotheenstraße, con su estructura arquitectónica histórica, tenían que ser construidos por arquitectos diferentes para aparecer como una estructura desarrollada. Por el contrario, las dos edificaciones en el "Cordón del Estado Federal" constituyen, programáticamente, grandes estructuras "nuevas" dentro del complejo total.

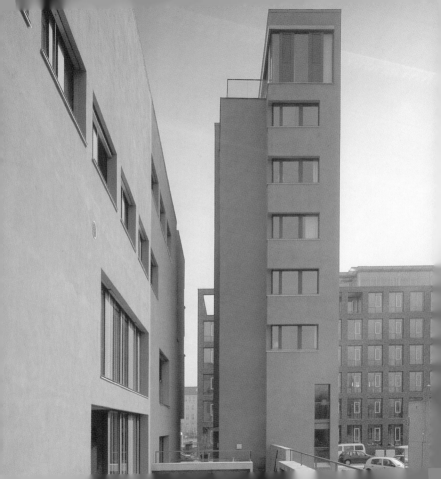

Landesvertretung Bremen
Federal State of Bremen Building

1996-1998
Hiroshimastraße 24
Tiergarten

www.leonwohlhagewernik.de

Hilde Léon, Konrad Wohlhage,
Siegfried Wernik

Die Landesvertretung besteht aus zwei sehr unterschiedlichen Baukörpern, die eine auffällige Rotfärbung verbindet. Insbesondere die Balkone des Turmbaus zitieren das Neue Bauen der 1920er Jahre. Der Turmbau soll zu der künftigen Blockrandbebauung am Landwehrkanal überleiten.

La représentation régionale se compose de deux bâtiments très différents d'une même couleur rouge très voyante. Les balcons de la tour rappellent la Nouvelle Architecture des années 20. Cette tour établira la transition avec les futures constructions en bordure d'îlot le long du Landwehrkanal.

The building in which the state of Bremen is represented consists of two very different sections connected only by their very unusual red exteriors. The balconies of the tower-like building, in particular, are reminiscent of the "Neues Bauen" of the 1920s. This tower is also intended to build a bridge to the future construction along the Landwehrkanal.

La representación del land consta de dos cuerpos arquitectónicos muy diferentes vinculados por una vistosa coloración rojiza. Especialmente los balcones de la torre remiten a la Nueva Construcción de los años 20. La torre habrá de conducir a la futura construcción junto al bloque en el Landwehrkanal.

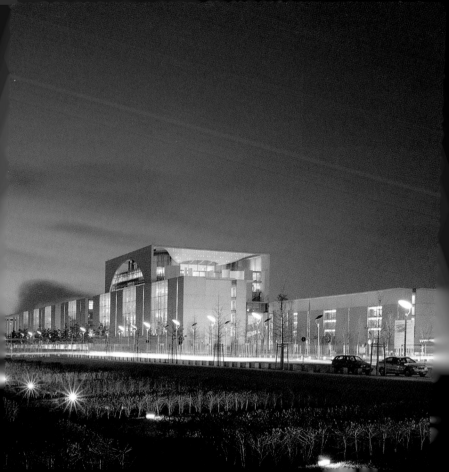

Bundeskanzleramt
Chancellery

1995-2001
Otto-von-Bismarck-Allee
Tiergarten

www.bundeskanzler.de
www.schultes-architekten.de
www.gse-berlin.de

Axel Schultes, Charlotte Frank, Christoph Witt
GSE Saar, Dieter Enseleit & Partner
(Structural Engineering)

Der im Inneren sehr leichte Bau ist Teil des „Band des Bundes" und programmatisches „Gegenüber" der Abgeordnetenbauten. Mit dem „Kanzlergarten" überquert er die Spree. Das Raumprogramm ist strikt anti-autokratisch: Konferenzräume liegen zentral, das Kanzlerbüro am Rand.

This airy building is part of the "band of federal building," and the "counterpart" of the representative's buildings. Its "Chancellor's Garden" spans the Spree. In the anti-autocratic floor-plan conference rooms are central, the chancellor's office peripheral.

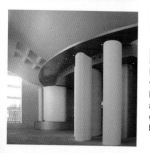

Ce bâtiment, d'une grande légèrèté intérieure, est part du « Ruban de la Fédération » et pendant programmatique des immeubles des parlementaires. Le « Jardin du Chancelier » traverse la Spree. Selon une distribution des espaces strictement anti-autocratique, les salles de conférence sont au centre et le bureau du chancelier en bordure.

La edificación, muy liviana en su interior, es parte del "Cordón del Estado Federal" y "contrapartida" programática frente a los edificios de los diputados. Cruza el Spree con los "Jardines del Canciller". El programa para el espacio es estrictamente antiautocrático: Las salas de conferencias están situadas en el centro, la oficina del Canciller en un margen.

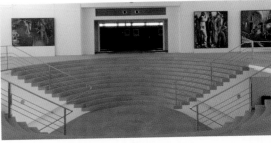

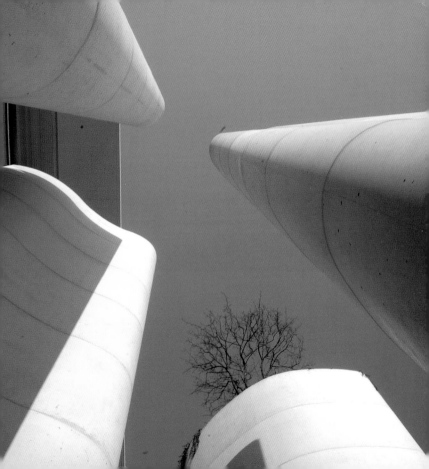

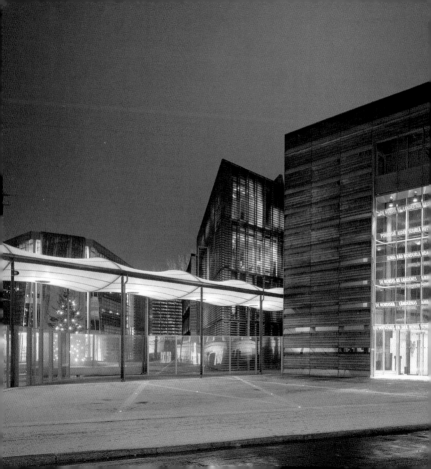

Nordische Botschaften
Nordic Embassies

1996-1999
Rauchstraße 1
Tiergarten

www.nordischebotschaften.org
www.berger-parkkinen.com
www.psp-architekten.de

Alfred Berger + Tina Parkkinen Architects,
Joachim Pysall, Peter Stahrenberg & Partner
(Masterplan & Felleshuset)

Der Nordische Rat (gegr. 1952) hat die Botschaftsbauten seiner Mitgliedsländer in einem Projekt zusammengefasst. Die fünf geografisch der Lage der Länder entsprechend angeordneten Einzelbauten werden von Kupferlamellen nach außen abgeschirmt. Neben dem Gemeinschaftshaus öffnet sich der Blick auf die einzelnen Vertretungen.

The Nordic Council (est. 1952) combined the embassies of members into one complex. The five buildings, arranged according to the geographic locations of the countries, are ensconced behind copper louvers. Next to the jointly used building, there is an unobstructed view of all of them.

Le Conseil nordique (fondé en 1952) a rassemblé en un projet commun les ambassades de ses pays membres. Les cinq bâtiments agencés selon la localisation géographique des pays correspondants sont protégés des regards extérieurs par des lamelles de cuivre. A côté du bâtiment commun la vue englobe les différentes représentations.

El Consejo Nórdico (fundado en 1952) reunió los edificios de las embajadas de sus países miembros en un proyecto. Los cinco edificios, dispuestos según la situación geográfica de los países, están protegidos hacia afuera por láminas de cobre. Junto a la casa común se vislumbra cada una de las representaciones.

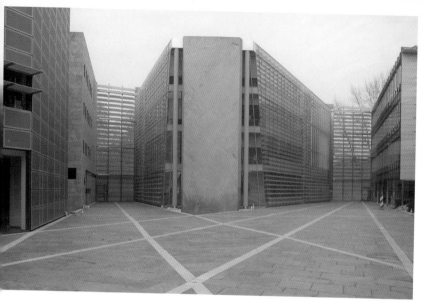

Lars Frank Nielsen & Kim Herforth Nielsen (Denmark)
VIIVA Arkkitehtuuri Oy, Rauno Lehtinen, Peka Mäki, Toni Peltola (Finland)
Pälmar Kristmundson (Iceland)
Snøhetta A.S., Christoph Kapeller, Kjetil Thorsen, Craig Dykers (Norway)
Gert Wingårdh Arkitektkontor AB (Sweden)

www.3xn.dk
www.snoarc.no
www.wingardh.se

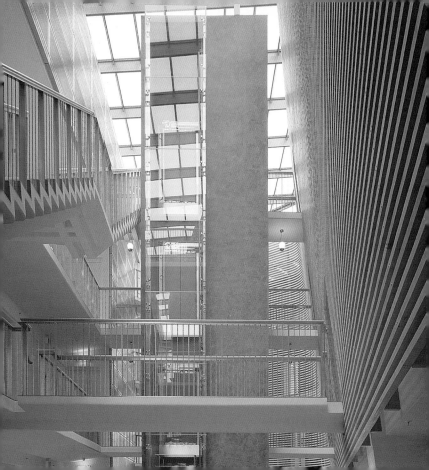

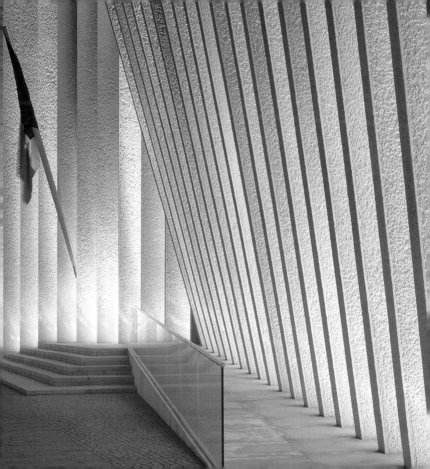

Mexikanische Botschaft
Mexican Embassy

2000-2001
Klingelhöfer Straße 3,
Rauchstraße 27
Tiergarten

www.embamex.de

Francisco J. Serrano, Teodoro González de León,
Pirkko Helena Petrovic & Heinz Dieter Witte

Schmale Pfeiler unterschiedlicher Schnitte bilden die Fassade aus. An der Eingangsseite treten sie zur Tür hin links gewändeartig, rechts an ihrem unteren Ansatz allmählich zurück. Dem Beton ist Marmor zugesetzt, der an der mit Presslufthämmern aufgerauten Oberfläche sichtbar wird.

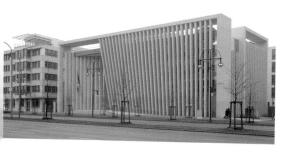

Slender pillars delineate the facade. To the left of the entrance they are slanted forward at an angle and on the right they gradually recede on their bases. Marble has been added to the concrete and is visible on surfaces roughly hewn by a pneumatic drill.

La façade est constituée de minces poteaux de section différente. A gauche de l'entrée ils avancent vers la porte comme un pied-droit-pour, à droite, s'esquiver graduellement à la base. La surface grenelée au marteau piqueur fait apparaître le marbre ajouté dans le béton.

La fachada se compone de pilares delgados en diferentes cortes. Por el lado de la entrada se dirigen, a la izquierda, hacia la puerta en forma de manto y a la derecha, en su parte inferior, retroceden progresivamente. Al hormigón se le ha añadido mármol el cual resulta visible en la superficie raspada con martillos neumáticos.

53

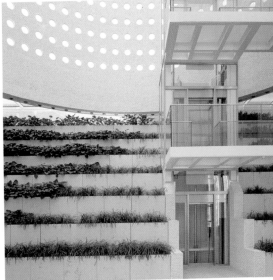

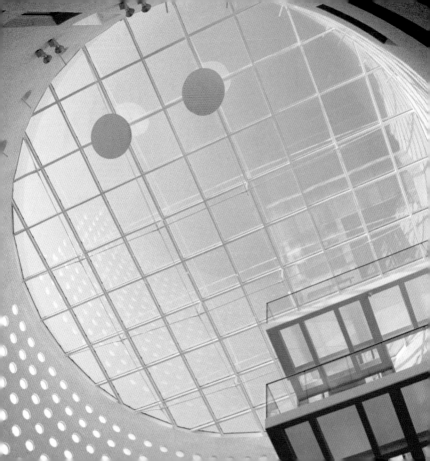

Österreichische Botschaft
Austrian Embassy

Hans Hollein

1999-2001
Stauffenbergstraße 1,
Tiergartenstraße 12
Tiergarten

www.oesterreichische-botschaft.de
www.pritzkerprize.com/hollein.htm

Das Gebäude bildet das Scharnier zwischen Kulturforum und Diplomatenviertel im Tiergarten. Es besteht aus mehreren Baukörpern, denen verschiedene Funktionsbereiche zugeordnet sind. In dem mit Kupfer verkleideten Bauteil werden Repräsentationsaufgaben wahrgenommen.

The building serves as a hinge between the "Kulturforum" and the diplomatic quarter in the Tiergarten district. It consists of a number of buildings that are each dedicated to different functions. Official receptions take place in the part of the complex that is faced with copper.

Le bâtiment forme la charnière entre le « Kulturforum » et le quartier des ambassades dans le Tiergarten. Il se compose de plusieurs corps affectés aux différentes fonctions. La partie habillée d'un parement de cuivre est destinée à l'exercice des tâches de représentation.

El edificio constituye la bisagra entre el "Kulturforum" y la barriada de los diplomáticos en Tiergarten. Consiste en varias construcciones a las que se han asignado funciones diferentes. En la parte del edificio revestido de cobre se desempeñan funciones de representación.

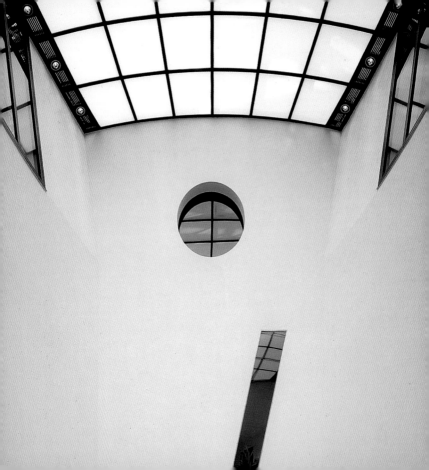

Potsdamer Platz
Office Buildings

Hilmer, Sattler & Albrecht (Masterplan)

1991-1998
Potsdamer Platz
Tiergarten

www.potsdamerplatz.de
www.sonycenter.de
www.h-s-a.de

Die Hochhäuser verbinden Sony- und Daimler-Areal. Der mittlere Turm greift formal die US-Skyscraper der 1930er Jahre auf, stuft das Volumen jedoch zur Straße hin nicht ab, sondern auf. Der linke Turm ist von expressionistischen Architektur-Utopien der 1910–20er Jahre inspiriert, der rechte vom Modernismus nach 1945.

These high-rises connect the Sony and Daimler complexes. The middle tower reflects typical 1930 US skyscrapers, but its volume is not reduced, but rather increased, toward the street. The left-hand tower was inspired by the Expressionist utopianism of the 1910s and 1920s, the right-hand one by postwar Modernism.

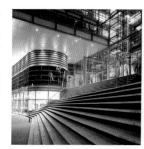

Les tours forment la jonction entre les complexes Sony et Daimler. La tour médiane, une référence aux gratte-ciel des années 30, s'achève côté rue par une gradation et non en dégradé. La tour gauche s'inspire des utopies architecturales expressionnistes des années 1910–20, la tour droite du modernisme d'après 1945.

Los rascacielos vinculan los recintos de Sony y Daimler. La torre mediana se hace eco de los rascacielos americanos de los años 30. Sin embargo, no escalona el volumen hacia arriba sino hacia la calle. La torre izquierda está inspirada en las utopías arquitectónicas expresionistas de los años 10 y 20, la derecha en la época moderna posterior a 1945.

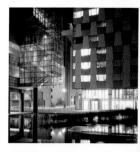

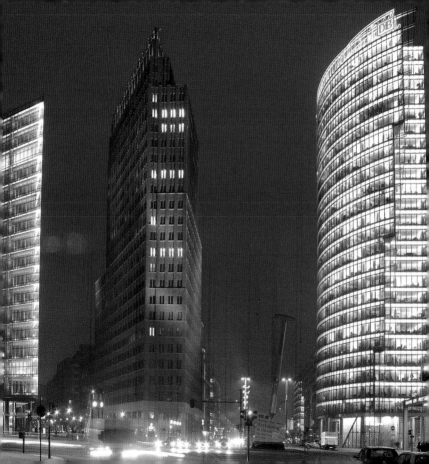

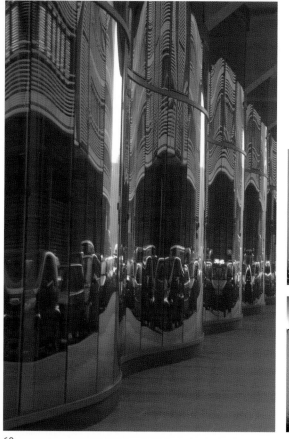

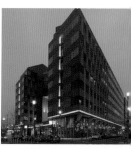

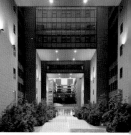

Murphy / Helmut Jahn (Bahn AG)
Hans F. Kollhoff, Helge Timmermann,
Jasper Jochimsen (Brick-cladded Office-Tower)
Renzo Piano Building Workshop, Christoph Kohlbecker,
Bernhard Plattner (Office Buildings + debis)
Arata Isozaki, Steffen Lehmann (Berliner Volksbank)
Richard Rogers (Office Building Linkstraße)
Ulrike Lauber & Wolfram Wöhr (Grimm-Haus)

www.murphyjahn.com
www.kollhoff.de
www.rpwf.org
www.kohlbecker.de
www.slab-berlin.de
www.richardrogers.co.uk
www.lauber-architekten.de

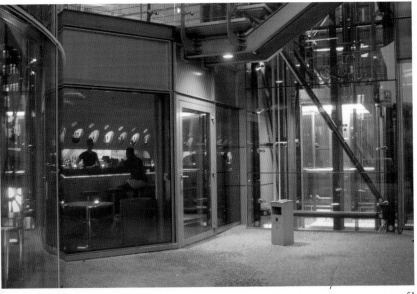

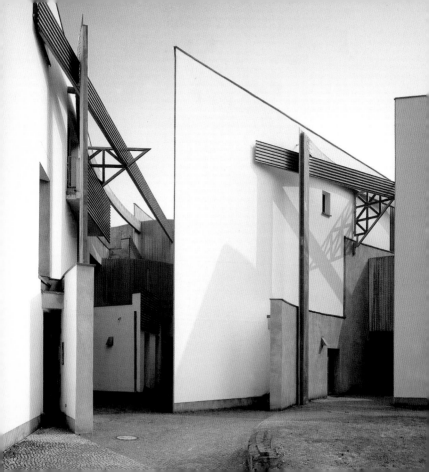

Heinz-Galinski-Schule
Jewish School

Zvi Hecker, Inke Baller

1990-1995
Waldschulallee 73-75
Charlottenburg

www.zvihecker.com

Zentrifugal streben die einzelnen keilförmigen Bauteile des ersten jüdischen Schulbaus in Berlin nach 1945 aus der Mitte. Zwei gewundene Wege verbinden die einzelnen Partien über drei Ebenen. Stahlstützen sind nicht wie im Neuen Bauen streng angeordnet, sondern dekonstruktivistisch verspielt.

Wedge-shaped building segments radiate from the center of this first Jewish school to be built in Berlin since 1945. Two winding paths connect the different parts on three levels. The steel supports are not arranged in an austere, but rather in a deconstructivist manner.

Les bâtiments cunéiformes de la première école juive construite à Berlin après 1945 rayonnent à partir d'un point centrifuge. Deux voies sinueuses relient sur trois niveaux les différents éléments. Les piliers d'acier ne sont pas agencés selon un ordre sévère mais s'inspirent du déconstructivisme.

Cada una de las partes cuneiformes del edificio de la primera escuela judía en Berlín tras 1945 se mueve desde el centro de forma centrífuga. Dos caminos serpenteantes unen cada una de las partes a tres niveles. Los soportes de acero no están dispuestos rigurosamente, como en la Nueva Construcción, sino de forma juguetona al modo deconstructivo.

Jüdisches Museum
Jewish Museum

Daniel Libeskind (Architecture)
GSE Saar, Enseleit & Partner, Ingenieursgruppe Wien
(Structural Engineering)
Günter Hönow (Reconstruction Berlin Museum)
Philip Gerlach (Original Building)

1988-1999
1734-1735 (Berlin Museum)
Lindenstraße 9-14
Kreuzberg

www.jmberlin.de
www.daniel-libeskind.com
www.gse-berlin.de

Ursprünglich als Anbau zum Berlin-Museum geplant, wurde das Gebäude eine eigene Attraktion, die Assoziationen wie „zerbrochener Davidstern", „Zugunglück" oder „Blitz" weckt. Der Entwurf basiert auf einem imaginären Liniennetz, das historische Punkte jüdischen Lebens in Berlin verknüpft.

Originally planned as an addition to the Berlin Museum, the building became an attraction in itself, awakening associations with a "broken star of David", a "train crash" or "a bolt of lightning." The design is based on an imaginary network of lines that can be drawn to important points in the lives of Jews in Berlin.

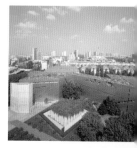

Initialement prévu comme une annexe du Berlin Museum, l'édifice est devenu une attraction à part entière. Il évoque une « étoile de David brisée », une « catastrophe ferroviaire », un « éclair ». Le concept s'inspire d'un réseau de lignes imaginaires reprenant les points historiques de la vie judaïque à Berlin.

Originalmente proyectado como construcción adicional al Museo de Berlín, el edificio se convirtió por sí mismo en una atracción que provoca asociaciones como una "estrella de David rota", un "accidente de tren" o un "rayo". El diseño se basa en una red imaginaria de líneas que remite a momentos históricos de la vida judía en Berlín.

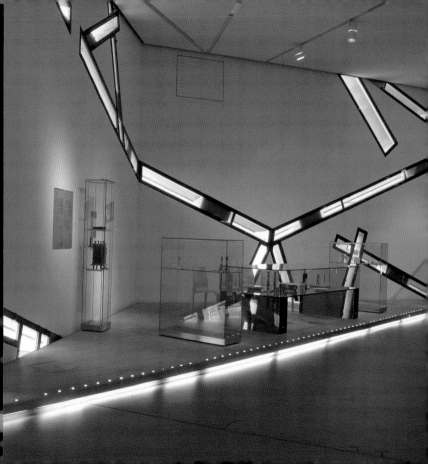

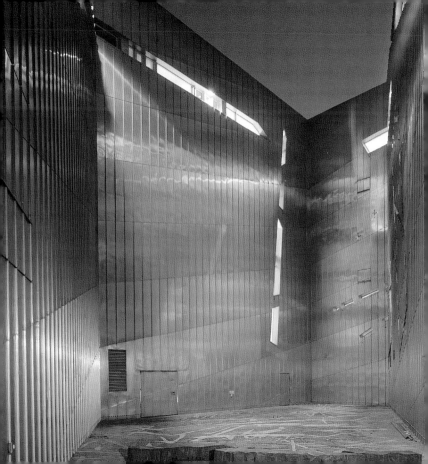

Topographie des Terrors
Memorial Site

Peter Zumthor

1993-2004
Stresemannstraße 140
Kreuzberg

www.topographie.de

Auf dem ehemaligen SS- und Gestapo-Gelände wurden Fundamente und Keller der zerbombten Bauten freigelegt. Sie bilden den Rahmen für die ständige Ausstellung der Stiftung Topographie des Terrors. Als Sitz der Stiftung entsteht ein Neubau nach Plänen Zumthors, deren elegant reduzierte Formen an Gefängnisgitter erinnern.

The foundations and cellars of SS- and Gestapo buildings, unearthed during excavation work, provide the context for the exhibition by the Topography of Terror foundation. It's new seat, now under construction, was designed by Zumthor. Its elegantly reduced forms remind one of prison bars.

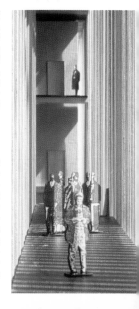

Des vestiges de fondations et de caves ont été dégagés à l'emplacement de l'ancien siège de la SS et de la Gestapo. Ils forment le cadre de l'exposition permanente de la Fondation Topographie de la Terreur. Cette fondation sera dotée d'un nouvel édifice conçu par Zumthor dont les formes élégamment épurées évoquent une grille de prison.

En el antiguo recinto de las SS y la Gestapo se excavaron los fundamentos y sótanos de los edificios bombardeados. Éstos son el marco de la exposición permanente de la fundación Topographie des Terrors. Como sede de la fundación surge un nueva edificacio según planos de Zumthor cuyas formas elegantemente reducidas, erocan los barrotes de una cárcel.

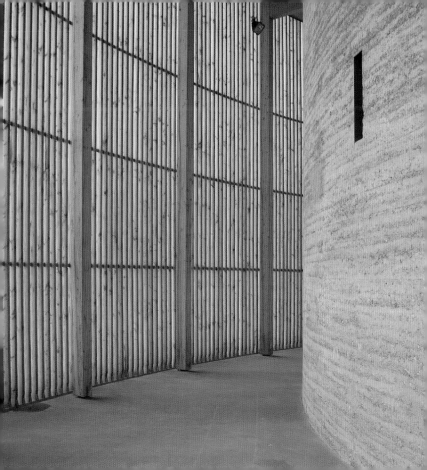

Versöhnungskapelle
Conciliation Chapel

1999-2000
Bernauer Straße 4
Mitte

www.kapelle-versoehnung.de

Rudolf Reitermann, Peter Sassenroth (Architecture)
Martin Rauch (Clay Building)

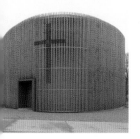

Bereits der Vorgängerbau der Kirche, von dem Spolien wiederverwendet wurden, trug dieses Patrozinium, das nun – auf dem ehemaligen Todesstreifen – umso treffender erscheint. Der ovale Bau besteht im Kern aus einem gestampften Lehmbau, um den ein Umgang aus Holzlatten geführt ist.

Even the original building on the site, from which decorative elements were taken to be used in this structure, was dedicated to this purpose. It now seems all the more appropriate considering its location on what used to be the death strip in no man's land. The core of the oval building is made of packed mud with a gallery made of wood.

L'église initiale dont on a réutilisé des vestiges portait déjà ce patronyme qui – à l'emplacement de l'ancien no-man's land – n'en est que plus pertinent. Le noyau de l'édifice ovale en terre battue est entouré d'une galerie ronde en lattes de bois.

Ya el edificio que precedió a la iglesia, del cual se reutilizaron espolios, tenía este patrocinio que ahora, en las antiguas franjas de la muerte, aparece todavía más apropiado. La edificación oval consiste esencialmente en una construcción de arcilla apisonada alrededor de la cual discurre una galería con vigas de madera.

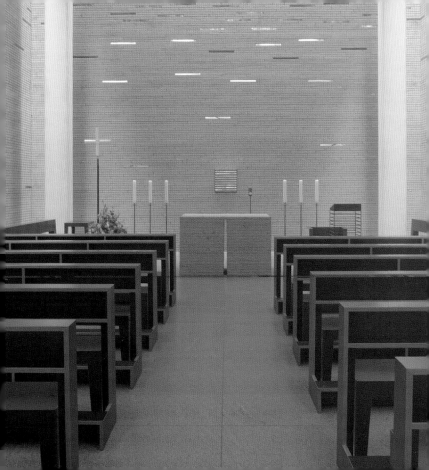

St. Thomas von Aquin

Katholische Akademie

1994-2000
Hannoversche Straße 5
Mitte

www.kath.de/akademie/berlin
www.kufus.de
www.rkw-as.de

Thomas Höger, Sarah Hare, Helmut Rhode,
Friedel Kellermann, Hans-Günter Wawrowsky (Architecture)
Norbert Radermacher, Axel Kufus (Design)

Höhepunkt des Tagungszentrums ist der Sakralbau, ein rechteckiger Raum mit niedrigerem Umgang. Im Hauptraum ist das flache Stahlbetondach wie ein gotischer „Gewölbebaldachin" auf vier Pfeilern eingestellt. Das seitlich steil abwärts einfallende Licht lässt die Struktur des Wandreliefs plastisch hervortreten.

The highlight of this conference center is the building used for worship, a square building with a lower gallery. In the main room, the flat roof of reinforced concrete rests on four columns like a "vaulted Gothic baldachin". The light that falls in from the side windows at a steep angle makes the relief on the wall take on a more plastic appearance.

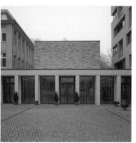

L'élément majeur du centre de conférences est constitué par cet édifice carré flanqué d'une galerie ronde. L'espace central est surmonté d'un toit plat en béton armé formant une « voûte gothique en baldaquin » posée sur quatre piliers. La lumière latérale oblique fait ressortir la structure du relief mural.

El punto álgido del centro de congresos es el edificio sacral, una habitación rectangular con galería baja. En la sala principal, el tejado plano de hormigón está colocado sobre cuatro pilares como un "baldaquín de bóveda" gótico. La luz, que entra por un lado hacia abajo de forma empinada, hace resaltar la estructura del relieve mural.

73

Häuser Sommer + Liebermann

Josef Paul Kleihues
Andreas Stüler (Original Buildings)

1996-1997
1844-1846 (Original Buildings)
Pariser Platz 1 + 7
Mitte

www.stiftung.brandenburgertor.de
www.kleihues.com

Die das ehemalige Stadttor flankierenden Gebäude sind Musterbeispiele „kritischer Rekonstruktion": Die Vorgängerbauten wurden nicht kopiert, sondern waren formales Vorbild für eine rationale Bebauung mit zahlreichen Abweichungen vom Original. So ersetzt z. B. ein Vollgeschoss das ursprüngliche Mezzanin.

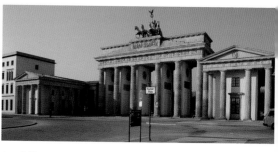

The two buildings that flank the former city gate are prime examples of "critical reconstruction". The buildings that originally stood on the site were not copied, but they did serve as formal models for the construction of more rational structures that include a number of variations. One of these was the decision to include a full floor in place of the original mezzanine level.

Les édifices encadrant l'ancienne porte de la ville illustrent de façon exemplaire la « reconstruction critique ». Les bâtiments initiaux n'ont pas été copiés mais ont inspiré une construction rationnelle présentant de nombreuses divergences par rapport à l'original. Ainsi la mezzanine a été remplacée par un étage carré.

Los edificios que flanqueaban la antigua puerta de la ciudad son modelos ejemplares de la "reconstrucción crítica": Los edificios precedentes no se copiaron sino que constituyeron un modelo formal para una edificación racional con numerosas divergencias respecto al original. Así, una planta completa, por ejemplo, sustituye al Mezzanin original.

Akademie der Künste
Academy of Arts

Günter Behnisch & Partner + Werner Durth
Ernst von Ihne (Reconstruction)

1993-2003
1905-1906 (Reconstruction)
Pariser Platz 4
Mitte

www.adk.de
www.behnisch.com

Der Neubau der Akademie weicht deutlich von den überwiegend steinernen Fassaden der übrigen Bebauung des Platzes ab, indem die erhaltene Bausubstanz der alten Akademie in einem transparenten Neubau präsentiert wird. Die vorgestellte Stahlstruktur nimmt die historische Fassadengliederung auf.

The new academy building differs markedly from the other buildings around the market place, with their mainly stone facades, because here the old building substance is presented behind a transparent new construction. The steel structure, that was erected in front of the old facade, can be seen to echo the historical one.

La nouvelle Académie diffère sensiblement des façades, majoritairement en pierre, des autres édifices de la place. Les vestiges de l'ancienne Académie se perçoivent dans la transparence du nouveau bâtiment. L'ossature métallique rapportée reprend l'articulation historique de la façade.

El nuevo edificio de la academia se aparta claramente de las fachadas, en su mayoría de piedra, del resto de la urbanización de la plaza presentando la estructura arquitectónica conservada de la antigua academia en un nuevo edificio transparente. La estructura de acero mostrada incorpora la división histórica de la fachada.

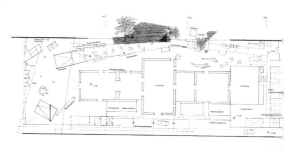

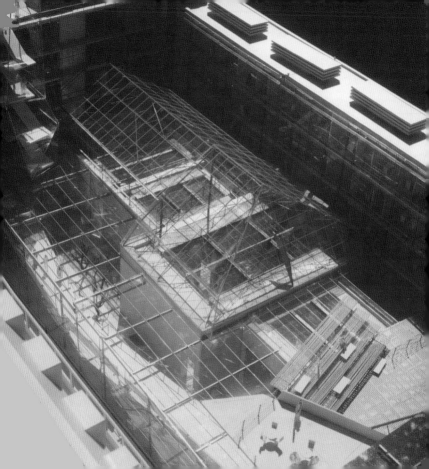

Mahnmal der Bücherverbrennung
Memorial Site of the Bookburning

Micha Ullmann (Artist)
Andreas Zerr (Architect)

1996
Bebelplatz 5 / Unter den Linden
Mitte

An dem Ort der Bücherverbrennung durch die Nationalsozialisten am 10. Mai 1933 befindet sich eines der gelungensten architektonischen Denkmäler Berlins: eine quadratische Glasplatte, tags kaum sichtbar, nachts hell leuchtend, öffnet den Blick in einen unterirdischen Raum mit leeren Bücherregalen.

On the site where the National Socialists staged book burnings, on 10 May 1933, one finds what is architectonically the most successful monument in Berlin—a square plate of glass, barely visible during the day, is brightly illuminated at night, providing a view of a room, below ground, that is filled with empty book shelves.

A l'emplacement où, le 10 mai 1933, les nationaux-socialistes brûlèrent les livres se trouve l'un des monuments commémoratifs à l'architecture la plus réussie : une dalle de verre carrée, presque invisible de jour, illuminée de nuit, permet au regard de plonger dans une bibliothèque souterraine aux rayons vides.

En el lugar de la quema de libros por parte de los nacionalsocialistas el 10 de mayo de 1933 se encuentra uno de los monumentos arquitectónicos más logrados de Berlín: Una placa cuadrada de cristal, apenas visible durante el día, brilla luminosa por las noches permitiendo ver una habitación subterránea con estantes vacíos de libros.

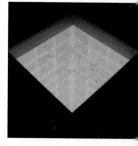

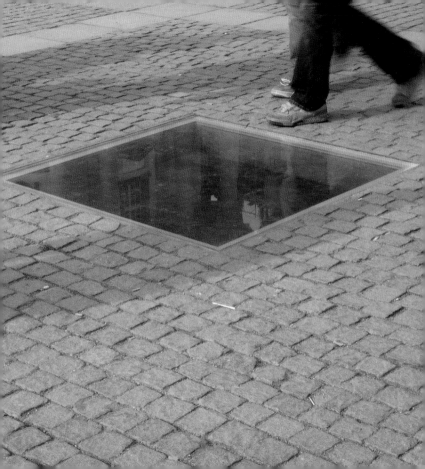

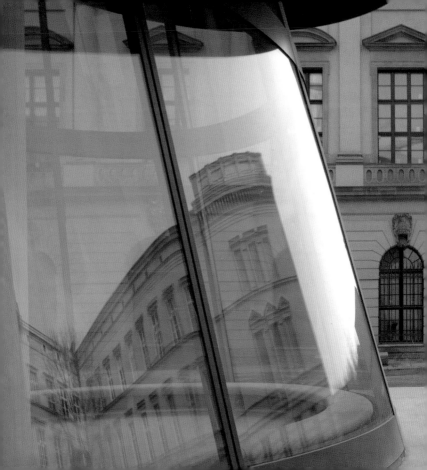

1999-2003
1695-1706 (Arsenal)
Hinter dem Gießhaus
Unter den Linden 3
Mitte

www.dhm.de
www.pritzkerprize.com/pei.htm
www.pcf-p.com
www.sbp.de

Deutsches
Historisches Museum
Museum of German History

Ieoh Ming Pei (Pei Cobb Freed & Partners) &
Gehrmann Consult
Schlaich, Bergermann & Partner
(Structural Engineering)
Johann Arnold Nering, Andreas Schlüter (Arsenal)

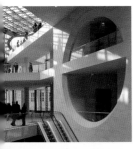

Hinter der auffälligen Treppe des Ausstellungsneubaus ist das Raumerlebnis vielleicht das eindrucksvollste Berlins: Die unterschiedlich ausgebildeten Etagen öffnen sich zum Foyer, das von Brücken überspannt wird. Die eigentlichen Ausstellungsräume ordnen sich unter.

Behind the remarkable stairway of the new exhibition building one can partake in what is probably one of the most impressive spatial experiences in Berlin. Each of the highly individual levels opens onto the foyer over which bridges are spanned. The actual exhibition spaces are subordinated to it.

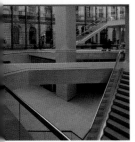

Derrière l'escalier original du nouveau bâtiment d'exposition la perception de l'espace est peut-être la plus impressionnante de Berlin : les niveaux de conception différente s'ouvrent sur un foyer surplombé par des passerelles auquel se subordonnent les salles d'exposition.

Detrás de las vistosas escaleras del nuevo edificio de exposiciones se vive la experiencia tal vez más impresionante en un interior de Berlín: Las plantas, conformadas de maneras totalmente distintas, se abren hacia el vestíbulo por el que cruzan puentes. Las verdaderas salas de exposición están dispuestas debajo.

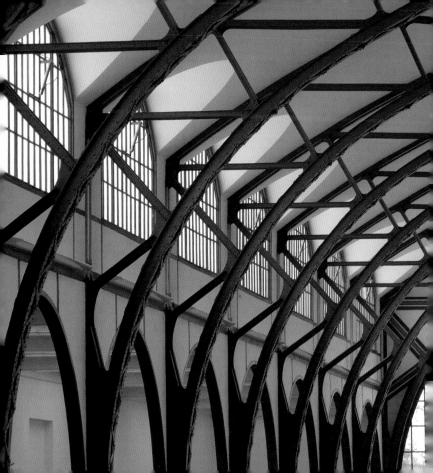

1990-1997
(Extension & Reconstruction)
1845-1847 (Original Building)
Invalidenstraße 50-51
Tiergarten

www.smpk.de/hbf/g.html
www.kleihues.com

Museum Hamburger Bahnhof

Josef Paul Kleihues (Architecture + Extension)
Ute Weström, Winnetou Kampmann (Reconstruction)
GSE Saar, Enseleit, Kropp & Partner (Structural Engineering)
Friedrich Neuhaus, Ferdinand Wilhelm Holz (Original Building)

Der spätklassizistische Kopf-bahnhof mit Neorenaissance-Türmchen dient nach Wieder-herstellung, Um- und Ausbau als Museum für Zeitgenössische Kunst. Die Konstruktion der Haupthalle ist ein historisches Zeugnis des Beginns der Moder-ne in der Baukunst.

The train terminal built in late-classicistic style with neo-Ren-aissance towers has served as a museum for contemporary art since it was refurbished and ren-ovated. The main hall can be seen as an historical landmark documenting the beginning of the modern age in architecture.

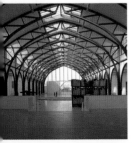

Restaurée, transformée et réa-ménagée, la gare de style classique avec ses tours néo-Renaissance abrite le musée d'art contemporain. La cons-truction du hall central est un témoignage historique des dé-buts de l'époque moderne en architecture.

Tras su reestablecimiento, refor-ma y ampliación, la estación ter-minal del clasicismo tardío con torrecitas neorrenacentistas fun-ciona como museo de arte con-temporáneo. La construcción de la nave principal constituye un testimonio histórico del inicio de la época moderna en la arqui-tectura.

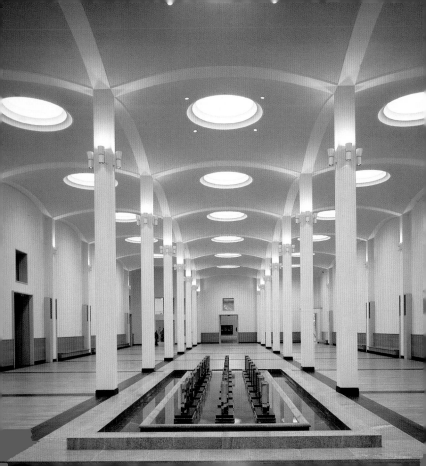

Gemäldegalerie
Gallery of Fine Arts

1988-1998
Matthäikirchplatz
Tiergarten

www.smb.spk-berlin.de
www.h-s-a.de

Hilmer, Sattler & Albrecht (Architecture)
Hans Scharoun (Kulturforum)
Rolf Gutbrodt (Original Building)

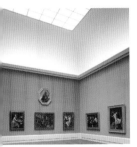

Das Kulturforum wurde bereits 1956 von Hans Scharoun projektiert. In der Neuen Gemäldegalerie gruppieren sich indirekt beleuchtete Kabinette und Säle um eine zentrale Halle, deren zahlreiche flache Gewölbe durch runde Öffnungen im Scheitel das Licht taghell und regelmäßig einfallen lassen.

The Kulturforum was originally planned by Hans Scharoun in 1956. The smaller exhibition spaces and larger rooms in the new Gemäldegalerie (painting gallery) have indirect lighting and are grouped around the central hall into which daylight falls through the regular succession of round openings at the top of the many relatively flat arches in the roof.

Le Kulturforum fut conçu par Hans Scharoun dès 1956. Dans la Nouvelle Galerie des Peintures les cabinets et salles éclairés indirectement s'articulent autour d'une halle centrale dont les nombreuses voûtes plates laissent passer l'éclairage naturel et régulier par des oculus zénithaux.

El Kulturforum fue proyectado ya en 1956 por Hans Scharoun. En la nueva Gemäldegalerie se agrupan los gabinetes y las salas indirectamente iluminadas en torno a una nave central cuyas numerosas bóvedas planas permiten que entre constantemente la luz del día a través de aberturas circulares en el vértice.

Krematorium
Baumschulenweg
Crematory

Axel Schultes Architekten,
Axel Schultes, Charlotte Frank,
Christoph Witt

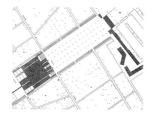

1996-1999
Kiefholzstraße 221
Treptow

www.schultes-architekten.de

Das feierliche Lichtspiel und die Würde des Baus entsprechen seiner Funktion. Die streng orthogonalen Grundelemente kontrastieren mit den frei angeordneten Rundpfeilern der zentralen Halle. Sie nehmen den Pflanzenbestand des Geländes auf.

The dignified interplay of daylight and decorum in this building underline its function. The basic elements, that are stringently rectangular, contrast with the cylindrical columns in the central vestibule that seem to be freely arranged. They reflect the vegetation on the site.

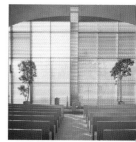

La fonction de l'édifice s'exprime dans la solennité de ses jeux de lumière et sa dignité. La sévérité des éléments orthogonaux contraste avec la liberté d'agencement des piliers ronds de la halle centrale qui rappellent la végétation avoisinant.

El ceremonioso juego de luces y la dignidad de la construcción corresponden a su función. Los elementos básicos, rigurosamente octogonales, contrastan con los pilares redondos de la nave central colocados libremente y albergan la vegetación del recinto.

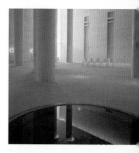

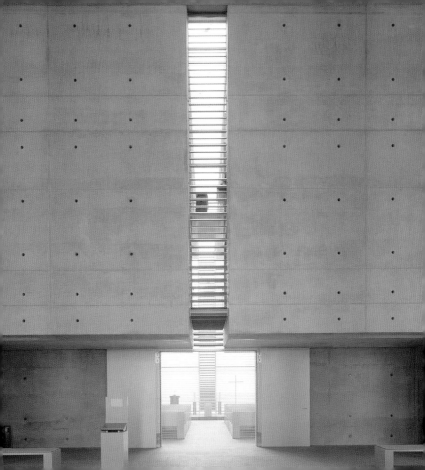

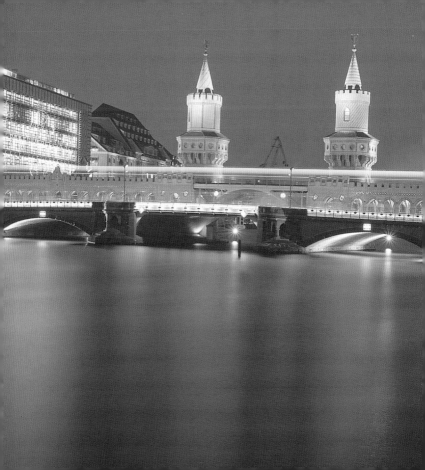

Oberbaum- & Kronprinzenbrücke

Santiago Calatrava Valls (Architecture)
Otto Stahn, James Hobrecht
(Original Oberbaumbrücke)

Oberbaumbrücke 1992-1995
(Original 1894-1902)
Stralauer Allee, Kreuzberg
Kronprinzenbrücke 1992-1994
Konrad-Adenauer-Straße, Mitte

www.stadtentwicklung.berlin.de
www.calatrava.com

Typisch für den Ingenieur-Architekten ist die Ausarbeitung der Konstruktionen zu zoologisch-skeletthaft wirkenden Formen. Die Kronprinzenbrücke scheint wie ein Tier vor dem Absprung, die Ergänzung der Oberbaumbrücke wirkt wie der Brustkasten eines Sauriers.

The skeleton-like formation of these bridges is typical of the designs executed by the so-called engineer-architects. The Kronprinzenbrücke looks like an animal crouching before it pounces, the addition to the Oberbaumbrücke reminds one of the ribcage of a dinosaur.

L'élaboration des constructions aux formes évoquant des squelettes est typique pour leur ingénieur et architecte. Le Kronprinzenbrücke rappelle un animal prêt à bondir, la partie complétant le Oberbaumbrücke la cage thoracique d'un saurien.

La realización de las construcciones como formas que parecen esqueléticas es típica del arquitecto-ingeniero. El Kronprinzenbrücke se asimila a un animal antes del salto, el complemento del Oberbaumbrücke produce la impresión de ser el tórax de un saurio.

89

Lehrter
Zentralbahnhof
Central Station

gmp - Meinhard von Gerkan,
Volkwin Marg & Partner (Architecture)
Jörg Schlaich, Rudolf Bergermann & Partner
(Structural Engineering)

1996-2006
Invalidenstraße,
Friedrich-List-Straße
Tiergarten

www.gmp-architekten.de
www.sbp.de

Der Bahnhof ist Knotenpunkt einer Ost-West- und einer Nord-Süd-Trasse, die in einem gewölbten „Langhaus" und einem doppelten „Querhaus" aufgenommen werden. Das Langhaus besteht aus filigranem, gebogenem Tragwerk, die Querhäuser aus massiven, streng orthogonalen Stahlkonstruktionen.

The train station is a hub of lines running from east to west and from north to south. In the one case they enter the arched "long house", in the other they enter two "perpendicular structures". The long house consists of a delicately arched supporting structure, the perpendicular buildings are massive, austere rectangular structures made of steel.

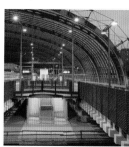

La gare marque le carrefour des lignes est-ouest et nord-sud intégrées dans un édifice longitudinal voûté et un double édifice transversal. L'édifice longitudinal est constitué d'une structure filigrane arquée, les deux édifices transversaux de constructions métalliques strictement orthogonales.

La estación constituye el nudo de comunicaciones de un trazado este-oeste y uno norte-sur recogidos en una "construcción longitudinal" de bóveda y una doble "construcción transversal". La longitudinal consta de alas arqueadas de filigranas, las transversales de construcciones masivas de metal estrictamente octogonales.

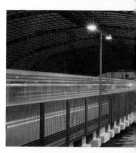

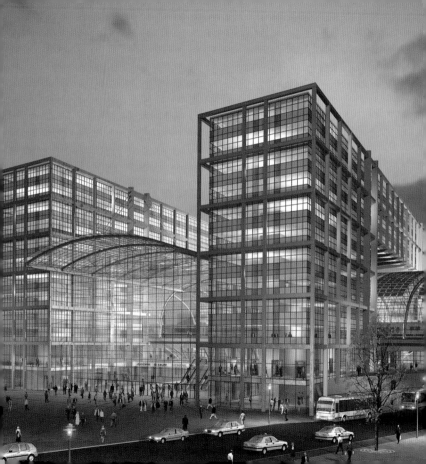

Bahnhof Potsdamer Platz
City Station

1997-2000
Potsdamer Platz
Tiergarten

www.stadtentwicklung.berlin.de
www.hermann-oettl.de
www.mofrei.de
www.h-s-a.de

Architektengemeinschaft:
Hermann + Öttl,
Modersohn & Freiesleben,
Hilmer, Sattler & Albrecht

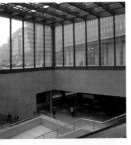

Die beiden oberirdischen Pavillons erinnern in der dezenten Glas-Stahl-Konstruktion an die nicht weit entfernte Neue Nationalgalerie Ludwig Mies van der Rohes (1965–1968). Unterirdisch verbinden sie die Sony- und Daimler-Areale mit S- und U-Bahn.

These two above ground pavilions, with their understated glass and steel construction, remind one of the Neue Nationalgalerie designed by Ludwig Mies van der Rohe (1965–1968), which is located nearby. Below ground they connect the Sony and the Daimler complexes with the commuter rail and the subway systems.

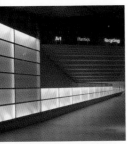

Les deux pavillons en surface rappellent par la décence de leur structure en verre et acier la Nouvelle Nationalgalerie de Ludwig Mies van der Rohe (1965–1968) toute proche. En sous-sol ils relient les complexes Sony et Daimler au réseau de métro et de S-Bahn.

En la discreta construcción de acero y vidrio, los dos pabellones sobre tierra recuerdan a la Nueva Galería Nacional de Ludwig Mies van der Rohe (1965–1968) que no se halla muy lejos. En el subterráneo, los recintos de Sony y Daimler los conectan con el tren urbano y el metro.

to stay . hotels

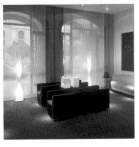

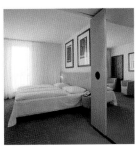

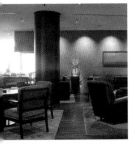

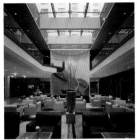

art'otel berlin mitte

Johanne + Gernot Nalbach (Architecture)
Georg Baselitz (Artist)

1998
Wallstraße 70-73
Mitte

www.artotel.de
www.nalbach-architekten.de

Der strengen Architektur des Hotels stehen 300 signierte Kunstwerke von Georg Baselitz gegenüber, der seit den 1980er Jahren einer der bekanntesten „Neuen Wilden" ist. Das „Ermelerhaus", ein überarbeitetes Rokokogebäude, nimmt Restaurants auf und stand ursprünglich in der Breiten Straße.

The austere architecture of the hotel stands in marked contrast to the 300 signed works of art by Georg Baselitz, considered one of the most famous "Neue Wilden" since the 1980s. The "Ermelerhaus", a revamped rococo style building that originally stood in the Breite Straße, provides space for restaurants.

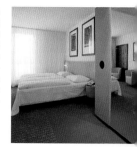

La sévérité de l'architecture de l'hôtel contraste avec les 300 œuvres signées Georg Baselitz, l'un des plus célèbres « Jeunes Fauves » depuis les années 1980. Les restaurants sont installés dans « Ermelerhaus », une maison baroque réaménagée et initialement située dans la Breite Straße.

Frente a la estricta arquitectura del hotel se hallan 300 obras de arte firmadas por Georg Baselitz quien, desde los años 80, es uno de los "Nuevos Impetuosos" más conocidos. La "Ermelerhaus", un edificio del rococó reestructurado, acoge restaurantes y estaba situado originalmente en la Breite Straße.

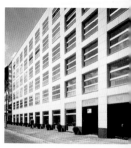

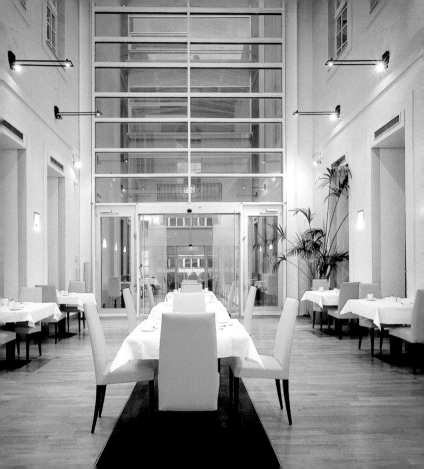

Dorint am Gendarmenmarkt

Harald Klein & Bert Haller

1999
Charlottenstraße 50-52
Mitte

www.dorint.de/berlin-gendarmenmarkt
www.klein-haller.de

Das in einem Jahrhundertwendebau untergebrachte Hotel wurde sachlich, mit edlen, unaufdringlichen Materialien eingerichtet. Einzelne Blickpunkte, wie Kunst aus der Entstehungszeit des Gebäudes, bieten ebenso spannende Kontraste wie die Verbindung der modernen Eingangssituation mit dem Altbau.

The hotel which is located in a building that dates back to the turn of the century was decorated in a functional style using a refined combination of understated materials. Individual highlights, like works of art from the period of the building's construction, provide exciting contrasts, as does the combination of the modern entry hall with the older building.

Installé dans un immeuble fin du siècle, l'hôtel présente un aménagement dépouillé utilisant des matériaux nobles et décents. Des accents individuels et œuvres d'art datant de l'époque de la construction de l'édifice forment des contrastes tout aussi captivants que l'alliance de l'entrée moderne avec le bâtiment ancien.

El hotel, alojado en un edificio de fin de siglo, se estructuró sobriamente mediante materiales nobles y discretos. Puntos concretos de interés, como el arte originario de la época en que surgió el edificio, ofrecen contrastes tan interesantes como lo es la vinculación de la entrada moderna a la construcción antigua.

99

Grand Hyatt

José Rafael Moneo Vallés

1993-1998
Marlene-Dietrich-Platz 2
Tiergarten

www.deutschland.hyatt.com
www.pritzkerprize.com

Dem dezenten Äußeren des Moneo-Baus mit einfacher Lochfassade entspricht die edle Innenarchitektur des ersten Grand Hyatts in Europa, die sich auf jeweils ein Gestaltungselement konzentriert. So wird das Bistro „Dietrichs" von einer Alabaster-Leuchtwand geprägt, die Lobby von einem „eingeschlagenen" Kristall.

The tasteful exterior of this Moneo building with its simple punctuated facade corresponds with the elegant interior of this, the first, Grand Hyatt in Europe. The focus is always on a single decorative element. Hence, the "Dietrichs" bistro is characterized by an alabaster wall illuminated from the back, the lobby, in turn, by a "crashing" crystal.

La décence de l'aspect extérieur du premier Grand Hyatt sur le continent européen conçu par Moneo, avec sa façade dépouillée, se prolonge dans la noblesse de son architecture intérieure. Celle-ci se concentre sur un élément unique, à l'exemple de la paroi lumineuse en albâtre dans le café « Dietrichs » ou du cristal « enfoncé » du hall.

La noble arquitectura interior del primer Grand Hyatt en Europa, concentrada en un elemento constitutivo respectivamente, concuerda con el discreto exterior del edificio de Moneo de fachada punteada simple. Así, el bistro "Dietrichs" se caracteriza por una pared luminosa de alabastro, el lobby por un cristal "roto".

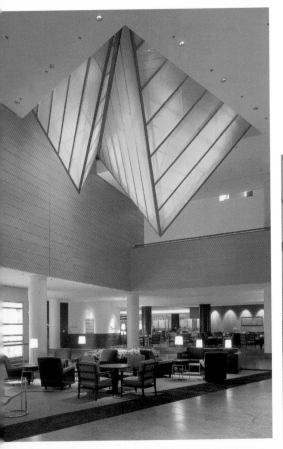

Hannes Wettstein, D9 Design (Interior Design Hotel and Restaurant)
Dani Freixes, Varis Arquitectes (Design Bistro Dietrichs)
Janice Clausen – Hirsch Bedner Associates (Design Lobby)
Maurice Brill (Light Design Lobby)

www.hbadesign.com
www.mbld.co.uk

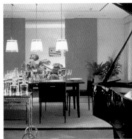

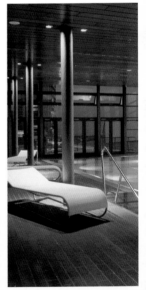

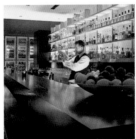

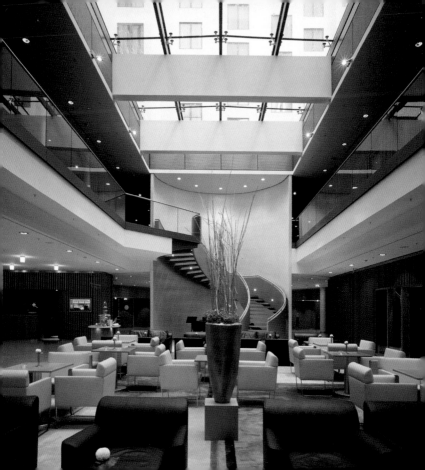

Swissôtel
am Ku'damm Eck

1998-2001
Kurfürstendamm 227-228
Charlottenburg

www.kudamm-eck.de
www.gmp-architekten.de

gmp – Mainhard von Gerkan,
Volkwin Marg & Partner

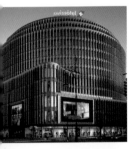

Zwischen dem zum Joachims-thaler Platz hin gerundeten Kernbau und der geraden Bauflucht des Kurfürstendamm vermitteln geschwungene Fassadenpartien, die das Gebäudevolumen dynamisieren. Die Bildschirmwand an der Fassade aus Aluminiumlisenen ist noch ein Motiv des Vorgängerbaus.

Between the rounded-off facade of the core building on the Joachimsthaler Platz and its straight alignment on Kurfüstendamm, curved sections of the facade mediate, making it more dynamic. The big aluminum projection screen was a motif from the previous building's facade.

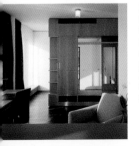

Les parties galbées de la façade dynamisent le volume architectural, trait d'union entre le bâtiment principal arrondi sur la Joachimsthaler Platz et l'alignement pur du Kurfürstendamm. Le mur écran à liserés d'aluminium est un motif conservé de la construction antérieure.

Entre la construcción principal curvada hacia la Joachimsthaler Platz y el límite recto prescrito para la edificación en el Kurfürstendamm median las partes onduladas de la fachada dinamizando el volumen del edificio. La pared con una pantalla de lisenen de aluminio en la fachada todavía es un motivo del edificio precedente.

Hotel Bleibtreu

Franziska Kessler (Interior Design)
Hubert Jacob Weinand (Architecture)

1995
Bleibtreustraße 31
Wilmersdorf

www.bleibtreu.com

Das Stadthaus der Gründerzeit beherbergt eines der fantasievollsten Berliner Hotels. Jede Etage ist anders gestaltet und unterscheidet sich in ihrer Farbigkeit. Die modernen Einbauten sind gefühlvoll in die alte Bausubstanz integriert.

The town house dating back to the belle époque is the home of one of the most unusual hotels in Berlin. Each of the floors features a different design and differs from the others even in the choice of colors. The modern fixtures are tastefully integrated into the older building substance.

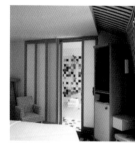

L'immeuble second empire allemand abrite l'un des hôtels berlinois les plus inventifs. Chaque étage est aménagé différemment et se distingue déjà par sa couleur. Les ajouts modernes sont intégrés avec une grande sensibilité dans le bâti ancien.

La casa de la ciudad originaria del período de la Gründerzeit acoge uno de los hoteles más imaginativos de Berlín. Cada planta está configurada de una manera distinta diferenciándose ya en su coloración. Las partes modernas están integradas con cariño en la estructura arquitectónica antigua.

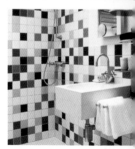

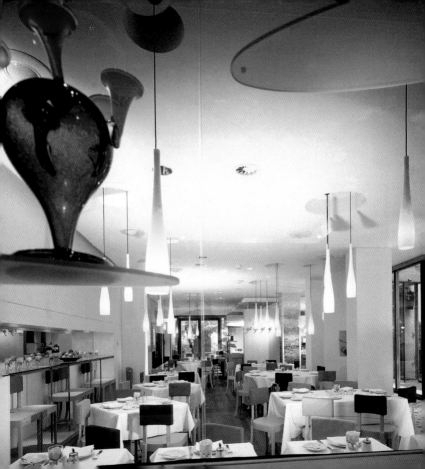

ku'damm 101

Kessler + Kessler (Design Concept)
Lemongras Design Studio (Rooms)
Hermann Weizenegger, Oliver Vogt (Public Area)

2003
Kurfürstendamm 101
Wilmersdorf

www.kudamm101.com
www.kessler+kessler.ch

Das Schwesterhotel des Bleibtreu ist dessen programmatisches Gegenstück: Puristisches Design bildet den Rahmen für ein auf High-Tech-Ausstattung spezialisiertes Hotel. Die dezente Farbigkeit geht auf die Farbreihen Le Corbusiers zurück. Auch die Möblierung mit Arne Jacobsen Stühlen und Cebranoholz verweist auf die Nachkriegsmoderne.

The Bleibtreu Hotel's sister is also its programmatic counterpart—puristic design and large forms create the context for a hotel specializing in high-tech furnishings. The subtle colors are drawn from Le Corbusier, while the furnishings, chairs by Arne Jacobsen and cebrano wood, are a reference to postwar modernism.

Jumeau et contraste à la fois du Bleibtreu. Design puriste et grands formats posent le cadre d'un hôtel qui se veut résolument high-tech. La décence des couleurs sérielles du Corbusier, l'ameublement et les sièges signés Arne Jacobsen, le bois cebrano sont autant de réminiscences historiques du modernisme d'après-guerre.

El hotel asociado con el Bleibtreu e su contrario prográmático: El diseño purista configura el marco para un hotel especializado en equipamiento de alta tecnología. Las discretas gamas de colores de Le Corbusier, también el mobiliario con las sillas de Arne Jacobsen y la madera de cebrano remiten de la postguerra.

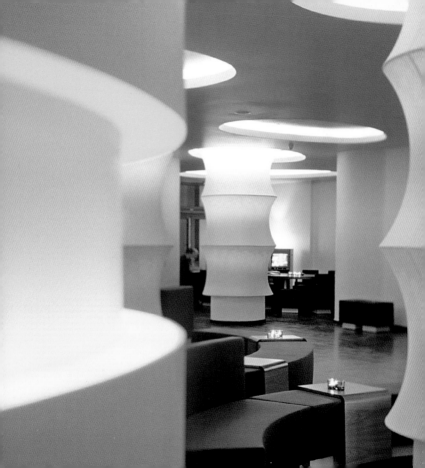

to go . eating
drinking
clubbing
leisure

Universum Lounge

Alexander Plajer & Werner Franz (Lounge-Design)
Jürgen Sawade (Reconstruction "Schaubühne")
Erich Mendelsohn (Original Cinema Building)

2001
1975–1981 (Reconstruction)
1927–1929 (Original Building)
Kurfürstendamm 153-163
Charlottenburg

www.schaubuehne.de
www.plajer-franz.de

Die Lounge gehört zu den schicksten in Berlin. Mit dem Namen sowie mit Einzelformen der Einrichtung und des Dekors nimmt sie Bezug auf die ehemalige Funktion des Baus als Universum-Kino im „Woga"-Komplex, einem der Hauptwerke zwischen Expressionismus und Neuem Bauen.

The lounge is one of the most fashionable in Berlin. The name—as well as some of the decorative elements in the interior—revert back to the building's original use as the Universum Cinema in the "Woga" complex, which was one of the prime examples of design between Expressionism and Neues Bauen.

Ce lounge compte parmi les plus chics de Berlin. Son nom et certaines formes de son aménagement et de son décor se réfèrent à l'ancienne fonction de l'édifice comme cinéma Universum dans le complexe « Woga », une réalisation architecturale majeure entre expressionnisme et Nouvelle Architecture.

El Lounge es uno de los más elegantes de Berlín. Con el nombre, así como con ciertas formas del equipamiento y de la decoración, remite a la antigua función del edificio del cine Universum en el complejo "Woga", una de las obras principales entre el expresionismo y la Nueva Construcción.

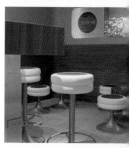

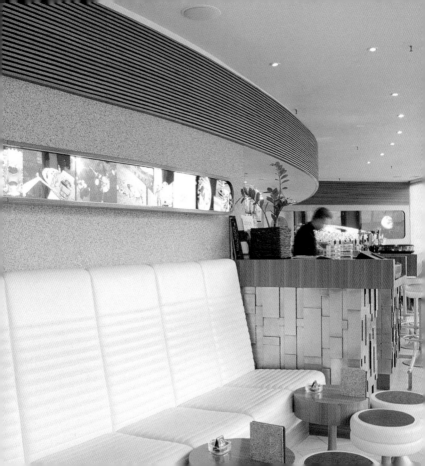

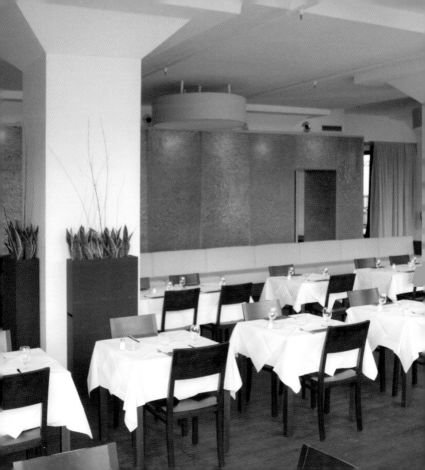

2003 (Restaurant)
1999-2001 (Reconstruction
"Spree-Speicher")
Stralauer Allee 1
Friedrichshain

www.fritz-fischer.de
www.buerozentral.de
www.wert-konzept.de (R. Müller)

Fritz Fischer

büroZentral – Uli Lechtleitner, Karin Sander,
Thomas Wolter (Restaurant)
Reinhard Müller (Reconstruction "Spree-Speicher")

Fritz Fischer befindet sich in einem ehemaligen Eierkühlhaus direkt an der Spree. Reinhard Müller zeichnet für die Revitalisierung des Baus sowie der benachbarten reduziert klassizistischen Speicher verantwortlich. Tagsüber Kantine der Universal Music Group, verwandelt es sich abends und an Wochenenden in ein Restaurant mit Cocktail Lounge.

Fritz Fischer is located in a former egg warehouse on the River Spree. Reinhard Müller revitalized the building and the adjacent, subtly Neo-Classical, warehouse. During the day, Fritz Fischer is the Universal Music Group's cafeteria, in the evening and on weekends, after noon, it becomes a restaurant and cocktail lounge.

Le Fritz Fischer est installé dans un ancien grenier à oeufs au bord de la Spree. La revitalisation de l'édifice et du grenier voisin, au classicisme dépouillé, est signée Reinhard Müller. Dans la journée le Fritz Fischer sert de cantine au personnel d'Universal Music, le soir et le week-end, à partir de 12 h, il devient restaurant et cocktail lounge.

Fritz Fischer se halla en un antiguo almacén frigorifico de huevos directamente a orillas del Spree. Reinhard Müller es responsable de la revitalización del edificio y del almacén vecino en estilo clasicista reducido. Durante el día cantina para el Universal Music Group, por las noches y los fines de semana a partir de las 12 horas se convierte en un restaurante con cocktail lounge.

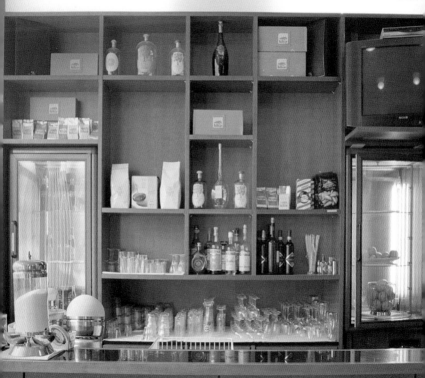

Sale e Tabacchi

1996
Kochstraße 18
Kreuzberg

Max Dudler

www.saleetabacchi.de
www.maxdudler.de

Name und Design des Bar-Restaurants verweisen auf Italiens früheres Staatsmonopol für den Salz- und Tabakverkauf. Die für Dudlers Architektur typischen klaren, distinguierten Formen finden sich hier in der Innenarchitektur wieder.

The name of this bar and restaurant is derived from Italy's traditional state monopoly on the sale of salt and tobacco and is reflected in the design. The clearly delineated forms, that are characteristic of Max Dudler's architecture, are also found in the interior.

Le nom et le design de ce bar-restaurant se réfèrent à l'ancien monopole de l'Etat italien sur la vente du sel et du tabac. Les formes claires, distinguées, typiques de l'architecture de Dudler, se retrouvent dans l'aménagement intérieur.

El nombre y el diseño del bar-restaurante remiten al monopolio italiano de antaño sobre la venta de sal y tabaco. Aquí, en la arquitectura interior se encuentran las formas típicas, claras y distinguidas, de la arquitectura de Dudler.

Café Bravo

Dan Graham, Gernot + Johanne Nalbach
Klaus-Peter Strach + Helmut Riehn (Structural Engineering)

1998
Auguststraße 69 (in the courtyard of the Kunst-Werke Berlin e.V.)
Mitte

www.kw-berlin.de
www.nalbach-architekten.de
www.strachundriehn.de

Das Café befindet sich in einem für die Berlinale 1998 errichteten, typischen Graham-Pavillon: Spiegelglas macht die Grenzen des Baus trotz seiner polierten Edelstahlkanten unscharf und verwischt innen und außen. Eine verspiegelte Rückwand potenziert diese Wirkung und vergrößert den Raum symmetrisch.

This café is located in a typical Graham pavilion, built for the Berlinale in 1998. Mirrored glass tends to distort the view of the actual limits of the space and despite highly polished steel edges the division between indoors and outdoors is blurred. The mirrors on the rear wall heighten this effect and symmetrically increase the size of the room.

Le café est situé dans un pavillon typique pour Graham édifié pour la Berlinale 1998. La glace cristal rend floues, malgré les arêtes en acier chromé, les limites de l'édifice et les estompe intérieurement comme extérieurement. Un panneau arrière en miroir multiplie cet effet et agrandit symétriquement l'espace.

El Café se encuentra en un típico pabellón de Graham construido para la Berlinale de 1998: El espejo hace borrosos los limites de la construcción a pesar de sus cantos de acero pulido y difumina interior y exterior. Una pared posterior de espejo potencia este efecto y agranda la sala simétricamente.

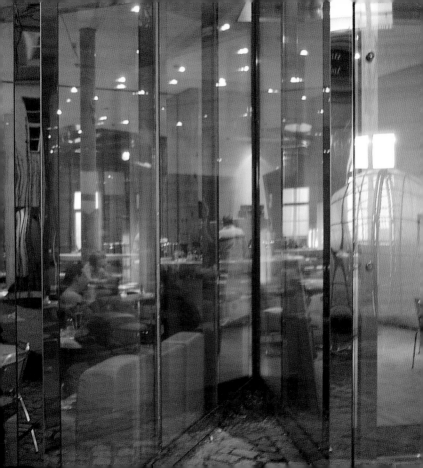

Vau

Peter Schmidt-Group (Design)
gmp – Meinhard von Gerkan, Volkwin Marg &
Partner (Architecture)

1997
Jägerstraße 54-55
Mitte

www.vau-berlin.de
www.peter-schmidt-studios.de
www.gmp-architekten.de

An der Stelle, an der Rahel Varn-hagen um 1800 ihren romanti-schen Salon unterhielt, befindet sich heute das von Peter Schmidt minimalistisch ausge-stattete Restaurant. Die Thonet-Freischwinger B64 mit Korbge-flecht wurden von Marcel Breuer 1928 entworfen, die Kunstwerke stammen von Oliver Jordan.

This restaurant, designed in min-imalist style by Peter Schmidt, is located on the site where Rahel Varnhagen hosted her Romantic Salon around 1800. The res-taurant features the Thonet can-tilever chair, B64, with cane seating which was designed by Marcel Breuer in 1928, the works of art are by Oliver Jordan.

A l'emplacement où, vers 1800 Rahel Varnhagen tenait salon, s trouve de nos jours le restaura aménagé en style minimalis par Peter Schmidt. Les chaise Thonet B64, à assise en rotin armature mobile, furent conçue en 1928 par Marcel Breuer. Le œuvres d'art sont signées Oliv Jordan.

En el lugar donde Rahel Varnha-gen mantuvo su salón romántico hacia 1800 se encuentra hoy el restaurante que Peter Schmidt equipó de forma minimalista. Las sillas Thonet-B64 de esteri-lla fueron diseñadas en 1928 por Marcel Breuer, las obras de arte proceden de Oliver Jordan.

Reingold

Corrado Signorotti
Signorotti-Rossetto-Martini Architetti Associati (Architecture)
Iris Schmied (Design)
Rinaldo Hopf (Artist)

2000
Novalisstraße 11
Mitte

www.reingold.de
www.rinaldokopf.de

Der tiefe Raum wird durch eine Onyxwand, einen langen Tresen und ein Podium an der Stirnwand in einzelne Bereiche unterteilt. Die Stirnwand füllt Rinaldo Hopfs Gemälde „Klaus & Erika Mann" (3,5 x 5 Meter, Wasserfarben und Tinte auf Buchseiten) aus, das motivisch und stilistisch auf die 1930er Jahre verweist.

This long space is divided into separate spaces by a wall of onyx, a long bar and a podium at the back. The back wall is filled by Rinaldo Hopf's painting "Klaus & Erika Mann" (3.5 x 5 meters, water color and ink on book pages) the motif and style of which refer to the 1930s.

Une paroi en onyx, un bar en longueur et une estrade bordant le mur frontal entrecoupent l'espace étiré. Le mur frontal est occupé par le tableau de Rinaldo Hopf intitulé « Klaus & Erika Mann » (3,5 x 5 m, gouache et encre sur pages de livre) dont le motif et le style s'inspirent des années 30.

El profundo espacio está dividido en áreas individuales mediante una pared de ónice, un largo mostrador y un podio en la pared frontal. La pared frontal está ocupada por el cuadro de Rinaldo Hopf "Klaus & Erika Mann" (3,5 x 5 metros, acuarela y tinta sobre páginas de libro) que, en motivos y estilo, remite a los años 30.

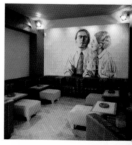

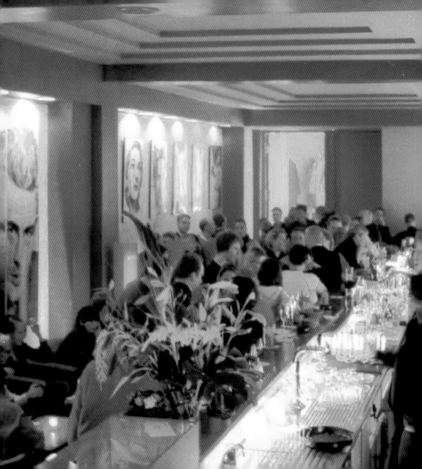

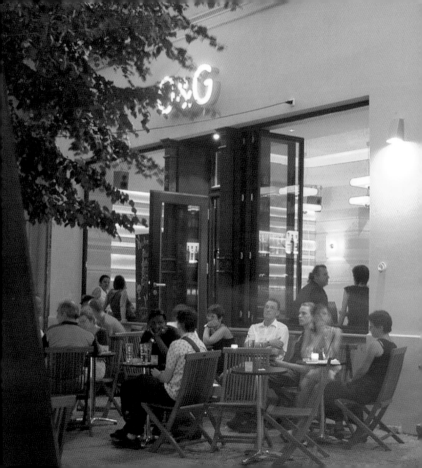

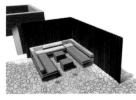

Obst & Gemüse

Philip Walter

2003
Oranienburger Straße 48
Mitte

www.obstundgemüse-bar.de

Die auch bei Touristen beliebte Bar leitet ihren Namen von dem Obst und Gemüseladen her, der sie zu DDR-Zeiten war. Farbige Streifendesigns und Accessoires spielen auf die Ästhetik der 1970er Jahre an. Das Café kooperiert mit dem angrenzenden "Freßko", in dem Snacks serviert werden.

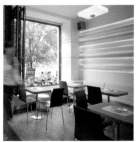

This bar, which is also popular with tourists, derives its name from the fruit and vegetable store that was located there in the GDR. Bright stripes and colorful accessories celebrate the aesthetics of the 1970s. The café cooperates with the nearby "Freßko", where snacks are served.

Apprécié également des touristes, ce bar doit son nom au magasin de fruits et légumes qu'il était à l'époque de la RDA. Rayures de couleurs et accessoires jouent l'esthétique des années 70. Le café coopère avec son voisin, le snack « Freßko ».

El nombre del bar, también popular entre los turistas, se deriva de la tienda de frutas y verduras que era en tiempos de la RDA. El diseño a rayas de colores y los accesorios remiten a la estética de los años 70. El café coopera con el contiguo "Freßko" donde se sirven snacks.

Cibo Matto

Frank Kemm

1999
Rosenthaler Straße 44
Mitte

www.cibomatto.de

Das Lokal wurde von dem Besitzer selbst gestaltet. Ein massiger Rundpfeiler bildet das Zentrum und trennt Café und Restaurant. Die Ausstattung konzentriert sich auf prägnante Elemente. Auffällig sind z. B. die schräg von der Wand abstehenden Lampen mit „Stehlampenschirmen".

The owner of this restaurant and café is also responsible for the interior design. A massive column marks the center of the space and separates the café from the restaurant. There is a singular focus on significant elements. Particularly interesting are the lamps that extend out from the walls diagonally with their "floor lamp shades".

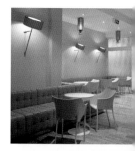

L'aménagement du local est l'œuvre de son propriétaire. Un pilier rond massif en marque le centre et sépare le café du restaurant. La décoration se concentre sur des éléments marquants, comme par exemple les lampes murales posées obliquement munies « d'abat-jour de lampadaires ».

El local fue configurado por el mismo propietario. Un pilar redondo masivo conforma el centro y separa el café y el restaurante. La decoración se concentra en elementos precisos: Espectaculares son, por ejemplo, las lámparas con "pantallas de lámparas de pie" que sobresalen de la pared de forma inclinada.

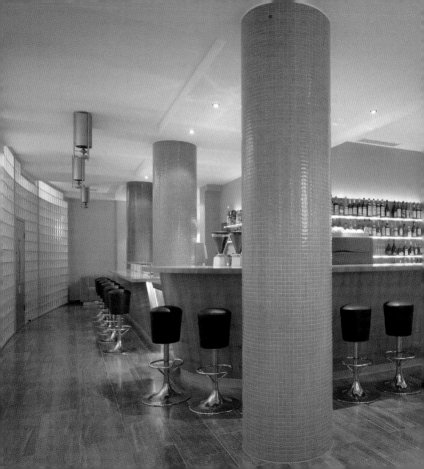

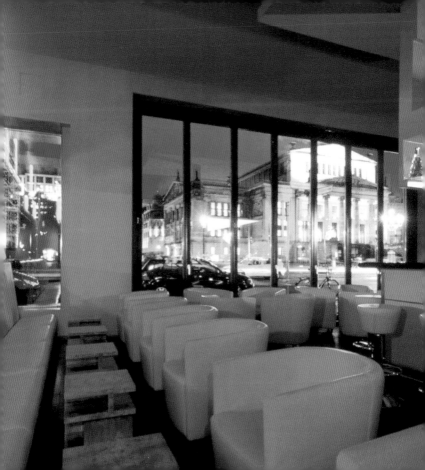

925 Lounge Bar

2000
Taubenstraße 19
Mitte

www.h-s-a.de

Hilmer & Sattler + Albrecht
Volker von Kardorff (Light Design)

Die Bar verdankt ihren Namen den 70 Kilogramm Sterlingsilber, die dem 18 Meter langen Tresen aufgelegt wurden. Dessen Glanz kontrastiert mit dem Fußboden aus Eichenparkett sowie der tiefrot und braun gehaltenen Ausstattung und ihren dunkelblauen Farbfeldern. Die acht Meter lange Glasfront öffnet den Blick zum Gendarmenmarkt. Sie lässt sich im Sommer öffnen.

The bar's name refers to the 70 kilograms of sterling silver with which the 18 meter bar is plated. Its luster stands in contrast to the oak floor and the dark red and brown furnishings with dark blue accents. A glass front, eight meters long, provides a view of the Gendarmenmarkt and can be opened in the summer.

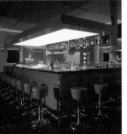

Le bar doit son nom au 70 kilos d'argent sterling habillant le comptoir de 18 mètres dont l'éclat contraste avec le parquet en chêne, le rouge profond et brun du décor avec ses champs bleu foncé. Les panneaux vitrés coulissants de 8 mètres s'ouvrent sur le Gendarmenmarkt.

El bar debe su nombre a los 70 kilogramos de plata esterlina que se colocaron en el mostrador de 18 metros de longitud. Su brillo contrasta con el suelo de parquet de encina así como con el equipamiento rojo intenso y marrón y sus partes azul oscuro. La fachada de vidrio, de ocho metros de longitud, permite ver el Gendarmenmarkt y en verano se abre.

129

drei

Wolfgang Kruse

2000
Lychener Straße 30
Prenzlauer Berg

www.restaurant-drei.de

Der Name des „drei" kommt von den drei Bereichen, die es unter einem Dach vereint: Restaurant, Lounge und Bar. Zahlreiche riesige Deckenlampen prägen die ansonsten unauffällige Raumgestaltung. Natürliche Materialien wie Holz, Leder, Stoff und Filz dominieren.

The name "drei" is derived from the three areas that are combined under one roof—a restaurant, lounge and bar. A number of enormous overhead lights dominate the otherwise inconspicuous interior. Natural materials like wood, leather, textiles and felt are paired with warm lighting.

« drei » tire son nom des trois espaces réunis sous son toit : restaurant, lounge et bar. De nombreux plafonniers géants rythment le décor au reste plutôt sobre. Les matériaux naturels (bois, cuir, tissu et feutre) dominent.

El nombre del "drei" viene de las tres áreas que une bajo un mismo techo: restaurante, lounge y bar. Las numerosas y enormes lámparas de techo caracterizan la configuración del espacio, por lo demás, poco llamativo. Los materiales naturales como la madera, la piel, el tejido y el fieltro se complementan con la cálida configuración de la luz.

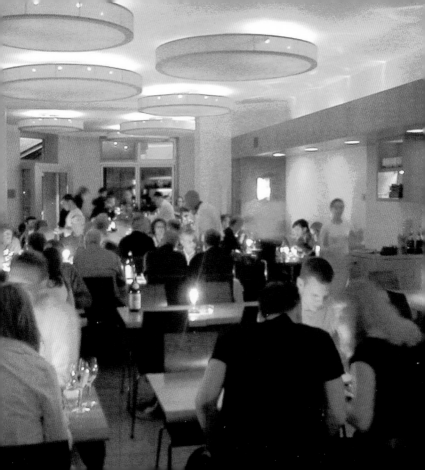

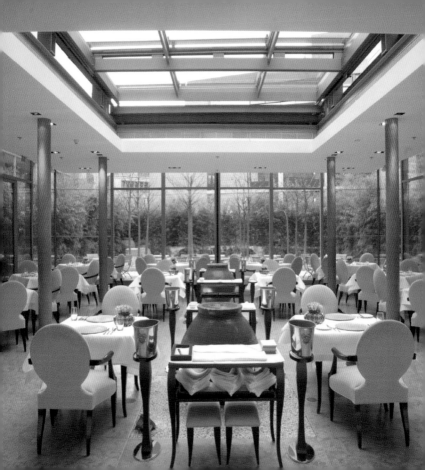

FACIL Restaurant & QIU Lounge

1999
Potsdamer Straße 3
Tiergarten

www.madison-berlin.de
www.facil.de
www.qiu.de

Lutz Hesse, Madison (Interior Design)
Flum Design (Architecture)

Das Restaurant „FACIL" und die „QIU Lounge" sind luxuriös ausgestattet und bestechen durch kunstvolle Arrangements und kleine Stilleben, die effektvoll beleuchtet werden. Das Madison Potsdamer Platz bietet vor allem komfortabel ausgestaltete Langzeitappartements.

The restaurant "FACIL" and the "QIU Lounge" are luxuriously appointed and feature enchanting artistic arrangements and small still-life scenes that are illuminated dramatically. The Madison Potsdamer Platz specializes, above all, in comfortably furnished residential suites.

Le restaurant « FACIL » et la « QIU Lounge » sont luxueusement équipés. Ils séduisent par leurs arrangements artistiques et petites natures-mortes remarquablement éclairés. Le Madison Potsdamer Platz offre surtout des studios longue durée confortablement aménagés.

El restaurante "FACIL" y el "QIU Lounge" están lujosamente equipados e impresionan por los artísticos arreglos y los pequeños bodegones espectacularmente alumbrados. El Madison Potsdamer Platz ofrece sobre todo apartamentos para estancias prolongadas decorados confortablemente.

133

Tempodrom & Liquidrom

gmp – Meinhard von Gerkan,
Volkwin Marg & Partner

2001-2002
Stresemannstraße 72
Kreuzberg

www.tempodrom.de
www.liquidrom.de
www.gmp-architekten.de

Das Tempodrom ist Nachfolger eines Zeltbaus und greift das Erscheinungsbild textiler Architektur auf. Formal steht die Betonschale (neo-)expressionistischen Tendenzen der 1950/60er Jahre nahe. Das Liquidrom folgt einem anderen Leitbild des Expressionismus: dem der Höhle.

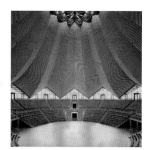

The Tempodrom was built take the place of a circus te and the architecture reflects th same sort of textile character. formal terms the concrete bo is closely related to the (Neo Expressionist tendencies of th 1950/60s. The Liquidrom reflec another Expressionist mode namely that of a cave.

Le Tempodrom succède à une tente dont il reprend l'aspect d'une architecture textile. La forme de l'enveloppe en béton rappelle les tendances (néo-) expressionnistes des années 1950/60. Le Liquidrom s'inspire d'une autre image phare de l'expressionnisme, celle de la caverne.

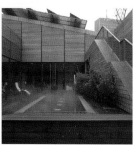

El Tempodrom es el sucesor d una construcción de carpa retoma la imagen de la arquitec tura textil. Formalmente, cubierta de hormigón está vir culada a tendencias (neo)expre sionistas de los años 50/60. llamado Liquidrom sigue otr modelo del expresionismo: el c la cueva.

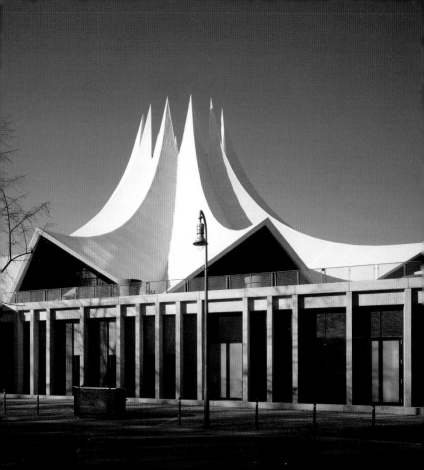

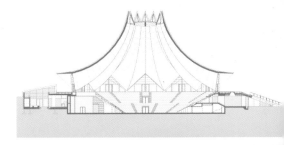

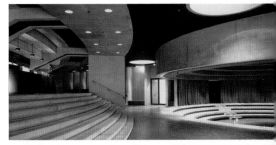

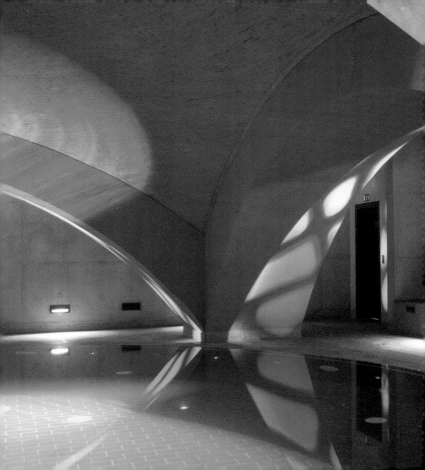

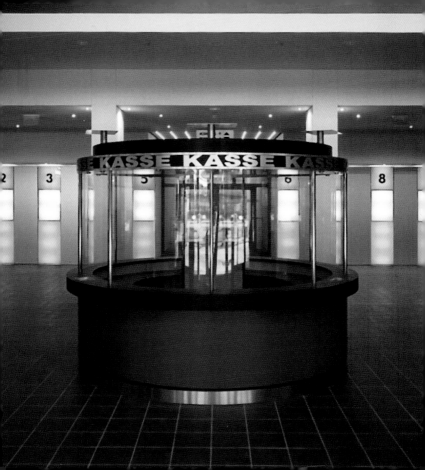

2000-2001
Rathausstraße 1
Mitte

www.ufakino.de/palcubix.htm
www.nps-partner-hh.de

Cubix Kino
Cinema

Nietz Prasch Sigl Tchoban Voss
(Architecture)
Julian Rosenfeld (Light Art)

Der Kubus aus Nero-Impala-Granit wird von vorstehenden Fensterbahnen horizontal gegliedert. Im Inneren beherrschen orthogonale Formen den Raum. Die Foyers werden abends in verschiedenen Farben beleuchtet. Die Lichtinstallation verkündet: „Ich glaube" „Nur was" „Ich sehe".

The ribbons of windows are set forward in this cube of Nero Impala granite and structure the facade horizontally. The interior is dominated by rectangular forms. In the evening, the foyers are illuminated in different colors. Light installations proclaim in German: "I believe" "only what" "I see".

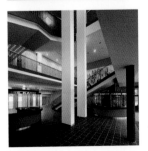

Le cube en granit impala nero s'agence autour des bandeaux de fenêtre filant horizontalement. L'espace intérieur est dominé par les formes orthogonales. Le soir, les foyers sont éclairés en différentes couleurs. L'installation lumineuse annonce : « Je ne crois que ce que je vois ».

El cubo de granito nero-impala está estructurado horizontalmente con hileras de ventanas salientes. En el interior, las formas octogonales dominan el espacio. Por las noches, los vestíbulos se iluminan en diferentes colores. La instalación de luces anuncia: "Yo creo" "sólo lo que" "veo".

SSE

Schwimm- und Sprunghalle im Europa-Sportpark & Velodrom

Dominique Perrault & Partner [APP], Rolf Reichert (Architecture)
Hans-Jürgen Schmidt-Schicketanz & Partner
Ove Arup & Partners (Structural Engineering)

1997
Landsberger Allee
Prenzlauer Berg

www.berlinerbaederbetriebe.de
www.velodrom.de
www.perraultarchitecte.com

Für die Olympiabewerbung 2000 entstanden diese beiden Hallen, deren größter Teil sich unter der Erde befindet. Ein großes Grasplateau umgibt die oberirdischen runden oder streng rechteckigen Bauteile, die über aufgeschüttete Böschungen erschlossen werden.

These two sports facilities, that are located mainly below ground, were built in conjunction with the bid for the 2000 Olympic games. On the street level, the austere circular and square building segments are surrounded by an expansive plateau of grass and can be accessed via embankments.

Ces deux halles, en majeure partie souterraines, furent construites en 2000 à l'occasion de la candidature de Berlin comme ville olympique. Un vaste plateau végétalisé entoure les édifices ronds ou strictement rectangulaires auxquels on accède par des talus en remblais.

Para la solicitud de los Juegos Olimpicos del 2000 surgieron estos dos pabellones cuya mayor parte se encuentra bajo tierra. Una gran esplanada de césped rodea las partes de la construcción redondas o estrictamente rectangulares situadas sobre tierra y que fueron erigidas por medio de terraplenes.

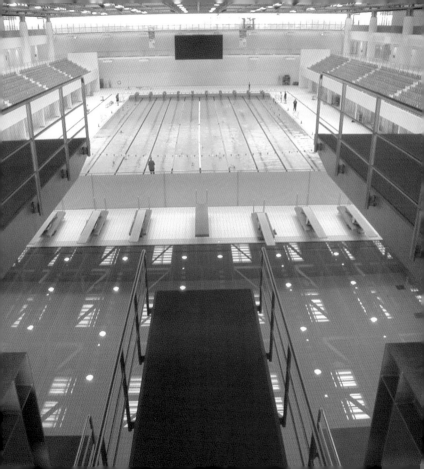

Potsdamer Platz
Entertainment

Renzo Piano Building Workshop, Christoph Kohlbecker,
Bernhard Plattner (Musical Theater, Casino, IMAX)
Ulrike Lauber & Wolfram Wöhr (CinemaxX)

1995-1998
Potsdamer Platz
Tiergarten

www.spielbank-berlin.de
www.imax-berlin.de
www.rpwf.org
www.kohlbecker.de
www.lauber-architekten.de

Architektonisch hervorzuheben sind das Musicaltheater und die Spielbank, die ein großes Dach miteinander verbindet. Sie kaschieren den Bruch, den die sich zum ehemaligen Grenzstreifen hin abschottende Staatsbibliothek von Hans Scharoun (1967–1976) in der wiedervereinten Stadt darstellte.

The musical theater and the casino, that are both connected by a large roof, deserve special architectonic mention. They play down the rift that the Staatsbibliothek, designed by Hans Scharoun (1967–1976), now seems to represent in the re-unified city, since it stood with its back to the former border strip.

On signalera l'architecture d complexe dédié aux comédie musicales et le casino reliés pa le même toit imposant. Ils ca chent la césure marquée dans ville réunifiée par la bibliothèqu nationale conçue par Har Scharoun (1967–1976) comm un écran bordant l'ancienr bande frontière.

En el plano arquitectónico hay que resaltar el Musicaltheater y el Spielbank unidos el uno con el otro por un gran tejado. Ocultan la irregularidad que representaba la Staatsbibliothek de Hans Scharoun (1967–1976) en la ciudad reunificada aislándose hasta la antigua franja fronteriza.

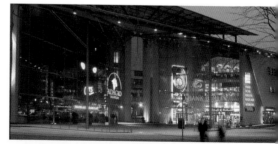

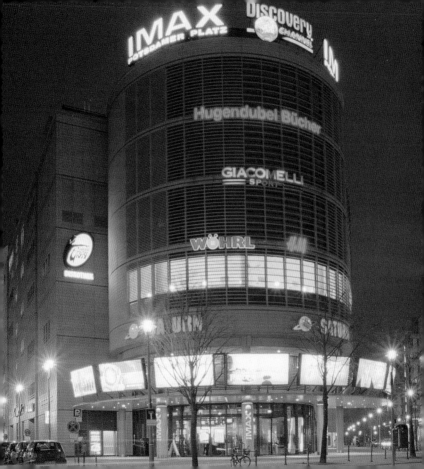

to shop . mall
 retail
 showroom

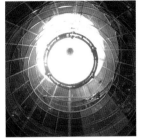

147

stilwerk

Novotny, Mähner & Assoziierte, Studio & Partners s.r.l.

1998-1999
Kantstraße 17-20
Charlottenburg

www.stilwerk.de/berlin/index.htm
www.nma.de

Das „Designkaufhaus" läuft wellenförmig auf die Straßenkreuzung zu. Dort sind die beiden Untergeschosse ausgespart, während die oberen auf Ständer gestützt vorkragen. Der Bau beherbergt zahlreiche aufwendig gestaltete Showrooms für Design, Möbel, Licht und Wohnaccessoires – Angebot und architektonisches Ambiente entsprechen einander.

Le « grand magasin du design » s'avance en vagues vers le carrefour. Les deux niveaux inférieurs sont évidés, tandis que les niveaux supérieurs étayés par des poteaux font ressaut. L'édifice accueille de nombreux showrooms de design, meubles, lampes et accessoires d'ameublement – offre et cadre architectural sont en harmonie.

This "Design Department Store" leads up to the intersection in waving lines. There the two lower levels are cut back while the upper levels are extended and rest on supports. The building provides space for numerous lavishly decorated showrooms for interior design, furniture, lighting and home accessories, which are in accordance with the architectonic ambience.

El "centro comercial de diseño" se dirige hacia el cruce en forma de olas. Allí se ahorraron las dos primeras plantas mientras que los pisos superiores sobresalen apoyados en soportes. La edificación aloja numerosas salas de exposición de diseño, muebles, luz y accesorios para la vivienda. La oferta y el ambiente arquitectónico se corresponden.

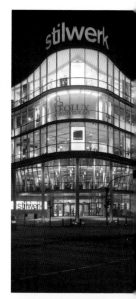

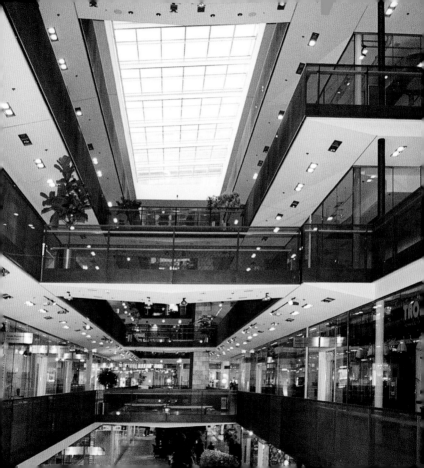

Patrizio Locatelli Rossi (Arclinea Store
Peter Maly (Ligne Roset Store
Alessandro Mendini (Alessi Store Mosaic

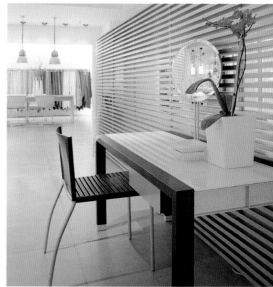

www.arclinea-berlin.de
www.peter-maly.de
www.ateliermendini.it

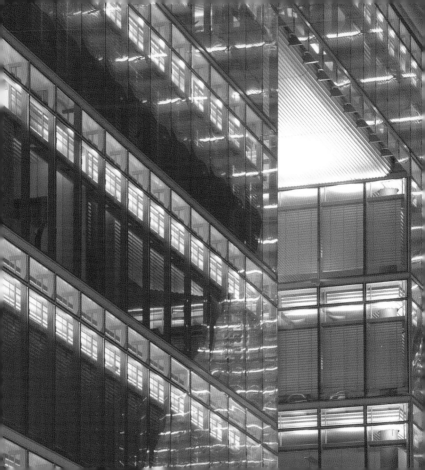

1997-2001 (Kranzlereck)
1957-1958 (Café Kranzler)
Kurfürstendamm 18-21,
Joachimsthaler Straße
Charlottenburg

www.neueskranzlereck.de
www.murphyjahn.com

Kranzlereck

Murphy / Helmut Jahn Architects
(Kranzlereck)
Yann Kersalé (Light)
Hanns Dustmann (Café Kranzler)

Der keilförmige Neubau Jahns ntstand anstelle eines geplan- en Zeilenbaus, der das Ensem- le des Café Kranzler mit eittypisch rundem Dachaufbau nd Kaufhaus dahinter vervoll- tändigen sollte. Der gläserne leubau distanziert sich formal on diesem Entwurf.

Jahn's wedge-shaped design was built in place of the longer rectangular building originally planned to complete the ensemble around the Café Kranzler. The café featured a glass rotunda on its roof that was typical of the period in which it was built. The design of the new glass building clearly distances itself from the older plan.

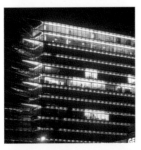

e nouvel édifice cunéiforme 'Helmut Jahn est venu rempla- er la rangée d'immeubles pré- ue pour compléter le complexe u Café Kranzler avec sa roton- e et le grand magasin à l'arriè- e. La forme du nouvel immeuble e verre fait totalement abstrac- on de ce projet.

La nueva edificación cuneiforme de Jahn surgió en el lugar de una proyectada hilera de edificios que debía completar el conjunto del Café Kranzler mediante una construcción del tejado circular, típica de la época, y un centro comercial detrás. La nueva edificación acristalada se distancia formalmente de este diseño.

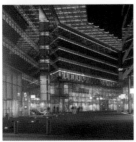

Mandarina Duck

Studio AMDL - Michele de Lucchi, Angelo Micheli,
Silvia Suardi + workshop, Michael Hilgers

2002
Kurfürstendamm 18-21
Charlottenburg

www.mandarinaduck.com
www.amd.it
www.workshopdesign.de

Das Schaufenster wird in den gesamten Verkaufsraum erweitert und die Produktpräsentation ist gänzlich von der Wand abgerückt. Die Regale greifen das organische Formenvokabular der Nachkriegszeit auf und führen dies in den tragenden Elementen konsequent fort.

The display window of the store extends all the way to the back of the retail space, and the product presentation has been completely moved away from the walls. The shelves draw on the vocabulary of organic forms that has been developed since the Second World War, it is also employed again in the supporting elements.

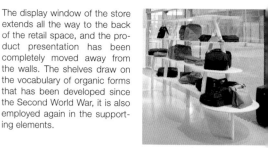

La vitrine se prolonge à l'intérieur du magasin et la présentation des produits s'est totalement écartée du mur. La forme des rayons adopte le vocabulaire organique de l'après-guerre qui est résolument repris dans les éléments porteurs.

El escaparate se amplía a toda la sala de ventas y la presentación del producto está totalmente retirada de la pared. Los estantes remiten al vocabulario orgánico de formas de la postguerra lo que se continúa consecuentemente con los elementos de soporte.

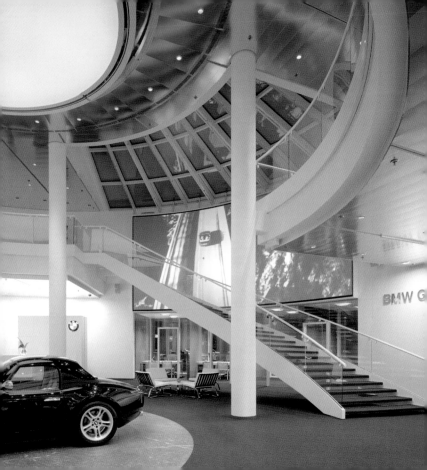

2002 (Showroom)
1993-1994 (Building)
Kurfürstendamm 31
Charlottenburg

www.bmw-berlin.de
www.plajer-franz.de

BMW

Fischer – Krüger – Rathai (Architecture)
Alexander Plajer & Werner Franz (Interior Design)

Den Bau zeichnet die Ecklösung in Form eines Zylinders aus. Der Showroom mit dem Atrium und der freischwebenden Treppe wirkt wie die Bühne klassischer Broadwayshows. Die dezente Farbigkeit der kreisrunden Ausstellungsräume meidet jedoch alles Reißerische.

Characteristic of this building are the corners that are marked by cylindrical forms. The showroom, with its atrium and suspended stairway, reminds one of a classic Broadway show. The choice of colors used in the circular exhibition rooms reflect a conscious decision to avoid anything that might be considered too sensational.

L'édifice marquant l'angle de l'îlot se distingue par sa forme cylindrique. Le showroom avec son atrium et sa volée d'escalier rappelle la scène des comédies musicales de Broadway. Absence totale de tape-à-l'œil et décence des teintes des salles rondes d'exposition.

La construcción se caracteriza por la solución de las esquinas en forma de cilindro. El showroom con el atrio y la escalera colgante produce el efecto de un escenario de los espectáculos clásicos de Broadway. La discreta coloración de las salas de exposición circulares evita, sin embargo, todo sensacionalismo.

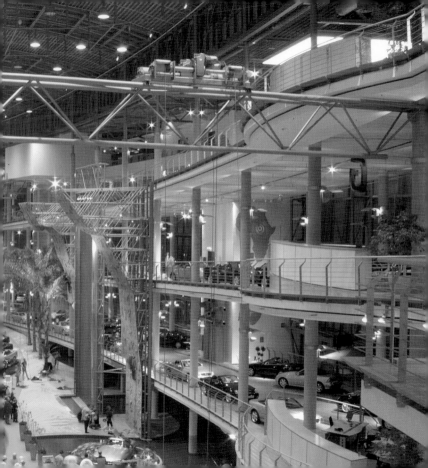

Mercedes-Welt

Günther Lamm, Wolfgang Weber,
Volker Donath & Partner

1997-2000
Salzufer 1-5
Charlottenburg

www.mercedes-welt.de

der 160 Meter langen, dem
preeverlauf folgenden Halle
tehen die Automobile in einer
rt „Freizeitpark", der sich auf
ner Rampe nach oben zieht.
ine Multimediawand, Spiel-
eugstraßen, Palmen an Tei-
hen, Café und Restaurant
rmöglichen einen ganztägigen
ufenthalt.

In this hall, which measures 160
meters and was built along the
course of the Spree, automo-
biles stand in a kind of "leisure
park" in which visitors are led
upwards along a ramp. A multi-
media wall, toy streets, ponds
surrounded by palm trees, a ca-
fé and a restaurant make it pos-
sible for visitors to spend the
whole day there.

Dans cette halle de 160 mètres
longeant le cours de la Spree les
automobiles sont présentées
dans une sorte de « parc de loi-
sirs » qui se prolonge vers le
haut par une rampe. Un mur
multimédia, des rues de jouets,
des étangs bordés de palmiers,
un café et un restaurant invitent
à y passer la journée.

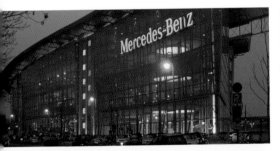

En la nave de 160 metros de
longitud que sigue el curso del
Spree, los automóviles se en-
cuentran en una especie de
"parque de atracciones" el cual
se arrastra hacia arriba sobre
una rampa. Una pantalla multi-
media, caminos con juguetes,
palmeras en estanques, un café
y un restaurante hacen posible
una estancia de un día entero.

Q 205

Oswald Matthias Ungers (Architecture)
John Chamberlain (Tower of Clythie)

1991-1996
Friedrichstraße 66-70
Mitte

www.q205.com

Ungers strenge quadratische Rasterung bestimmt die Flächendekoration und die einzelnen Baukörpern sowie deren Verhältnis zueinander. Kunstwerke – insbesondere der „Turm von Klythie" – stehen in spannungsreichem Verhältnis hierzu. Die gestaffelten Bauvolumina greifen den Typus „hohe Stadtbebauung" auf.

Unger's stringently quadratic matrix determines the design of the facade, as well as the relationship of the individual building segments to each other. Works of art—particularly the "Turm von Klythie"—provide exciting contrasts. The staggered building volumes can be seen as a reference to a "city skyline."

La trame strictement carrée de Unger détermine la décoration des surfaces, les différents corps du bâtiment et leur interrelation. Un rapport captivant s'établit avec les œuvres d'art – en particulier la « Tour de Clythie ». Les volumes échelonnés de l'édifice s'apparentent au type « d'architecture urbaine en hauteur ».

La retícula de Unger, austera y cuadrada, condiciona la decoración de la superficie y cada una de las partes arquitectónicas así como la relación de las unas con las otras. Con ello contrastan las obras de arte, sobre todo la "Turm von Klythie". Los volúmenes arquitectónicos escalonados retoman el tipo de la "alta edificación urbana".

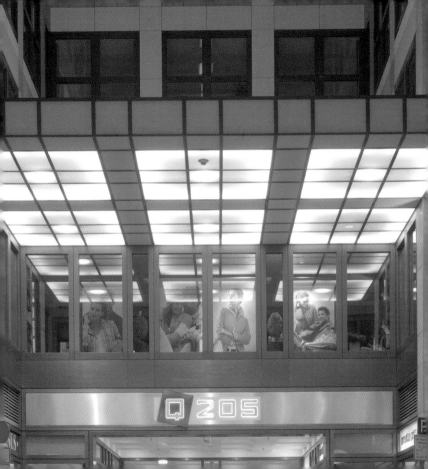

Quartier 206

Henry Cobb of Pei, Cobb, Freed & Partners

1991-1996
Friedrichstraße 71-74
Mitte

www.quartier206.com
www.pcfandp.com

Der kantige Außenbau und die einem Kristall nachempfundene Kuppel, die das Atrium überspannt, scheinen vom Expressionismus inspiriert. Die dekorative Verkleidung des Inneren hingegen ist eher dem Art Déco verwandt. Geschwungene Treppen verweisen auf barocke Anlagen.

The building's angular exterior and dome spanning the atrium, which was modeled after a crystal seem to have been inspired by Expressionism. The interior decorations, on the other hand, are more closely related to Art Deco. While the curving stairways seem more reminiscent of Baroque castles.

La façade angulaire du bâtiment et sa coupole cristalline à facettes surplombant l'atrium semblent inspirées de l'expressionnisme. Les parements intérieurs s'apparentent plutôt à l'Art Déco. La courbure des escaliers se réfère au baroque.

La construcción exterior esquinada y la cúpula, que imita un cristal y cubre el patio, parecen inspiradas por el expresionismo. En cambio, el revestimiento decorativo del interior más bien está unido al Art Déco. Las escaleras onduladas remiten a edificaciones barrocas.

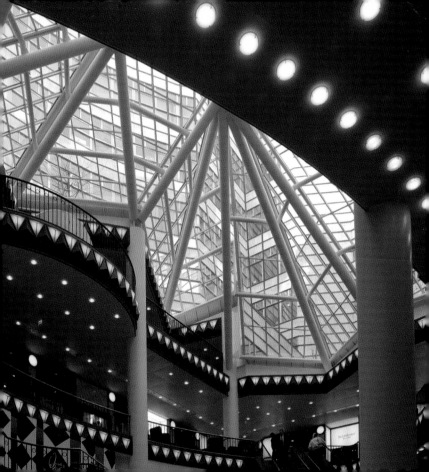

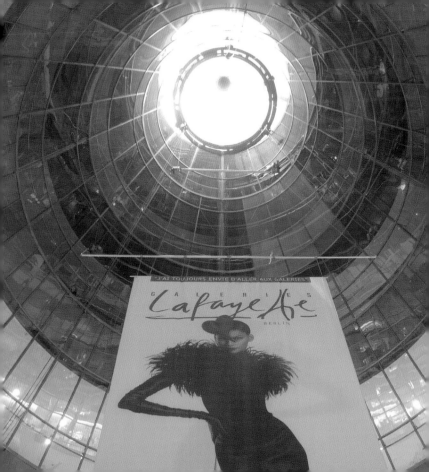

Quartier 207

Galeries Lafayette

1991-1996
Friedrichstraße 76-78
Mitte

www.lafayette.de

AJN, Architectures Jean Nouvel

Auf originelle Weise erinnert Nouvel an die berühmte Glaskuppel des Pariser Stammhauses der Galeries Lafayette: Ein riesiger Lichtkegel durchdringt den Baukörper von oben, von unten kommt ihm ein Glastrichter entgegen. Kleinere Kegel belichten die Büros im übrigen Bau.

In a rather unusual manner, Nouvel reminds us of the glass dome on the original Galeries Lafayette store in Paris. An enormous cone of light penetrates the building from above, from below a glass funnel extends up toward it. Smaller glass cones serve to illuminate the offices in the rest of the building.

Jean Nouvel réinvente de façon originale la célèbre coupole de verre des Galeries Lafayette parisiennes. Un immense cône de verre traverse le bâtiment de haut en bas, auquel répond, dans sa partie inférieure, un cône inversé. De petits cônes éclairent les bureaux situés dans le reste du bâtiment.

De una manera original, Nouvel recuerda a la famosa cúpula de cristal de la sede de las Galeries Lafayette en París: Una enorme esfera luminosa atraviesa el cuerpo arquitectónico desde arriba, desde abajo le viene al encuentro un embudo de vidrio. Esferas más pequeñas alumbran las oficinas en el resto del edificio.

Brille 54

Alexander Plajer & Werner Franz

1997-2000
Rosenthaler Straße 36
Mitte

www.brille54.de
www.plajer-franz.de

Der Brillenladen schafft mit klaren, modernen Mitteln Platz auf kleinstem Raum. Er steht im Gegensatz zum Hof, der einem dekororientierten Neoeklektizismus folgt und den Raum optisch verengt. So erinnern die Gitter an Jugendstil und das Dach an anthroposophische Architektur.

In this relatively small optician's shop a spacious appearance is created by using clearly structured, modern elements. This stands in sharp contrast to the courtyard where a decorative neo-eclecticism prevails, causing the space to appear more limited. Hence, the gate is reminiscent of Art Nouveau, while the roof seems to be inspired by anthroposophic architecture.

Le magasin d'optique, avec sa clarté et son modernisme, exploite l'espace au maximum contrastant avec la cour dont le décor néo-éclectique contribue au rétrécissement optique de l'espace. Ses grilles rappellent l'Art nouveau et l'architecture du toit est d'inspiration anthroposophique.

Con medios claros y modernos, la tienda de gafas crea espacio en un lugar muy pequeño y se contrapone al patio el cual sigue un neoeclecticismo orientado a la decoración y encoge el espacio ópticamente. Así, las verjas recuerdan al modernismo y el tejado a la arquitectura antroposófica.

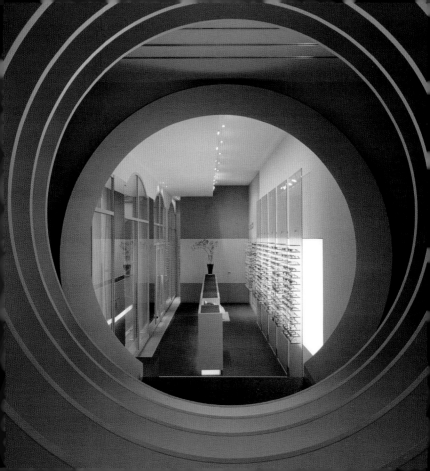

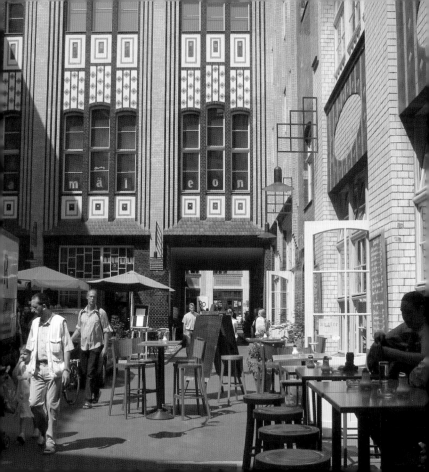

1999 (Gap between Buildings)
1999 (Art Pavilion)
1995 (Galerie Aedes)
1995-1996 (Reconstruction)
1904-1907 (Original Building)
Rosenthaler Straße 40-41
Mitte

www.hackesche-hoefe.com
www.unstudio.com
www.nps-partner-hh.de
www.gruentuch-ernst.de

Hackesche Höfe

Armand Grüntuch, Almut Grüntuch-Ernst (Gap between Buildings)
Nietz Prasch Sigl Tchoban Voss (Art Pavilion)
Ben van Berkel (Aedes East)
Fabrik No. 40, Matthias Faust / Stefan Weiß (Reconstruction Street Façade)
Kurt Berndt (Original Building)
August Endell (Original 1. Courtyard)

Die sieben Höfe wurden aufwendig saniert und durch moderne Architektur bereichert. Die ursprüngliche Funktionsdurchmischung aus Geschäften, Wohnen, Kultur und Büros wurde beibehalten und wird weiter ausgestaltet. Der Galeriebau dient der Architekturgalerie Aedes als Ausstellungsraum.

The seven courtyards were extensively renovated and enhanced by modern architecture. The original mix of functions, which included retail, residential, cultural and office spaces, was maintained and further expanded. The gallery building is used by the Aedes Architectural Gallery as an exhibition space.

Les sept cours ont été rénovées à grands frais et revalorisées par des éléments architecturaux modernes. Le mélange initial de magasins, logements, institutions culturelles et bureaux a été conservé et encore développé. L'une des ailes accueille les expositions de la galerie d'architecture Aedes.

Los siete patios fueron laboriosamente reformados y enriquecidos mediante una arquitectura moderna. La original combinación de tiendas, viviendas, cultura y oficinas se mantuvo y se sigue desarrollando. La construcción de la galería le sirve a la galería de arquitectura Aedes como sala de exposiciones.

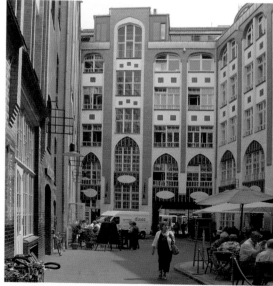

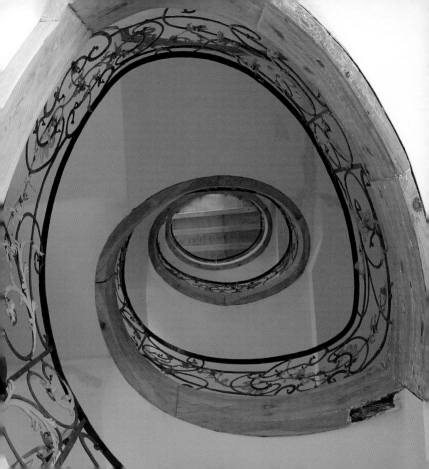

Orlando Schuhe

plan4

2000
Rosenthaler Straße 48
Mitte

www.orlando.de
www.planvier.de

Den Ausbau über zwei Etagen strukturieren offene Gestaltungselemente: Die eigens gefertigten Regale erlauben Durchblicke auf den gesamten Raum und lassen ihn so größer erscheinen. Statt geschlossener Reihen bilden sie verschiedene Bühnen, auf denen mit Licht Schuhe inszeniert werden.

This two-story space is structured by open elements. The shelving, that was purpose-built, allows for views to be seen through it, thereby making it seem larger. Instead of forming closed ranks, it creates different stages on which the shoes are set in scene using appropriate lighting.

Les deux niveaux sont structurés par des éléments d'aménagement ouverts : les rayons conçus spécialement permettent au regard d'englober l'espace dans sa totalité en le faisant paraître plus grand. Point de rangées fermées mais différentes scènes où les chaussures sont animées par des effets de lumière.

Los elementos abiertos estructuran la construcción a dos plantas: Los estantes, confeccionados expresamente, permiten una visión de conjunto sobre toda la sala haciéndola así aparecer más grande. En lugar de hileras cerradas, forman diferentes escenarios sobre los que se escenifican los zapatos con la ayuda de la luz.

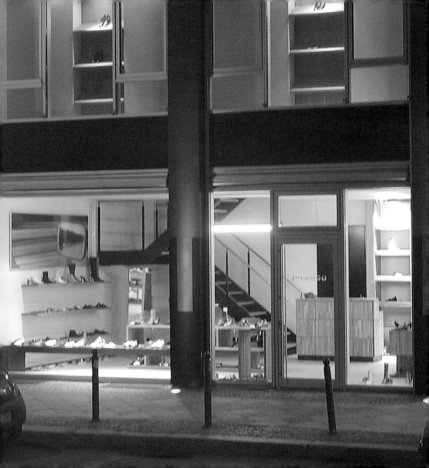

Hallen am Borsigturm

Claude Vasconi & Partners
Dagmar Groß

1994-1999

Am Borsigturm 2,
Berliner Straße 27
Tegel

www.borsighallen.de
www.hallen-am-borsigturm.de
www.claude-vasconi.fr

Die neuen Hallen mit teilweise versetzten, alten Fassaden bilden ein autarkes Stadtteilzentrum. Im Inneren werden auf verschiedenen Ebenen und in einem zentral in einer der Hallen stehenden Turmbau ebenso wie in nur von außen zugänglichen Bereichen umfassende Freizeit- und Shoppingmöglichkeiten angeboten.

The new buildings, some of which are staggered to include old facades, form an autarc city center. Inside they offer extensive leisure and shopping opportunities in a centrally located tower within the complex, as well as in areas that can only be reached from outside.

Les nouvelles halles avec leurs anciennes façades partiellement en retrait forment un centre urbain autarcique. L'intérieur offre des possibilités multiples de loisirs et d'emplettes sur divers niveaux, dans une tour centrale implantée dans l'une des halles ainsi que dans des zones accessibles uniquement depuis l'extérieur du complexe.

Las nuevas naves, parcialmente con antiguas fachadas cambiadas de lugar, conforman un centro de barrio autárquico. En el interior, a distintos niveles y en una torre situada en el centro de una de las naves así como en recintos accesibles solamente desde el exterior, se ofrecen amplias posibilidades para el ocio y las compras.

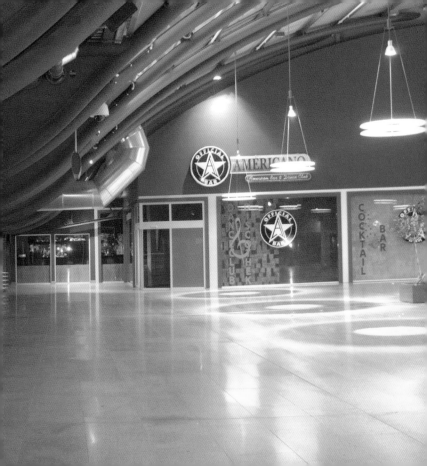

1995-2000
Neue Potsdamer Straße,
Kemperstraße, Bellevuestraße
Tiergarten

www.sonycenter.de
www.sonystyle-europe.com
www.murphyjahn.com
www.designcompany.de

Sony-Center
Sony Style Store

Murphy / Helmut Jahn Architects (Architecture)
DesignCompany (Sony Style Store)

Die zentralen Bauten des Sony-Komplexes sind für Jahn typische Kombinationen sachlicher Baukörper mit aufwendigen Bedachungen. In diesem Beispiel wird das Forum von Segeln überspannt. Der Style Store präsentiert die Produkte wie Kunstwerke in Vitrinen.

The main buildings in the Sony complex combine functional structures with extravagant roofs as is typical of Helmut Jahn. In this case sails are spanned over the forum. The Style Store presents Sony products in display cases like works of art.

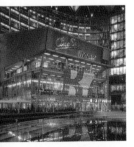

Les édifices centraux du complexe Sony allient, selon une formule typique pour Jahn, corps fonctionnels et toitures sophistiquées. Ici le forum est surmonté d'une voilure. Dans le Style Store les produits sont exposés dans des vitrines comme des œuvres d'art.

Las edificaciones centrales del complejo de Sony constituyen las típicas combinaciones de Jahn de sobrios elementos arquitectónicos con laboriosos tejados. En este ejemplo, el foro se recubre con lonas. El Style Store presenta los productos en vitrinas como obras de arte.

Potsdamer Platz Arkaden

Renzo Piano Building Workshop,
Christoph Kohlbecker, Bernhard Plattner

1991-1998
Neue Potsdamer Straße,
Eichhornstraße
Tiergarten

www.ece.de
www.rpwf.org
www.kohlbecker.de

Zentrum des Daimler-Areals sind die Arkaden, eine Einkaufspassage, die zwischen verschiedenen Bauten aufgespannt ist. Piano und Kohlbecker schufen den Masterplan des Areals. Viele andere Architekten, die am Wettbewerb teilgenommen haben, wurden mit Einzelbauten beauftragt – s. „Potsdamer Platz – Office", Seite 58.

The Arkaden is the name of a shopping passage that spans the space between different buildings in the Daimler complex. Renzo Piano and Christoph Kohlbecker created the master-plan for the complex. Many of the other architects who took part in the competition were commissioned to design individual buildings–s. "Potsdamer Platz—Office" p. 58.

Le centre du complexe Daimler est occupé par les Arkaden, une galerie marchande qui relie différents édifices. Le masterplan du site est signé Piano et Kohlbecker. De nombreux autres architectes ayant participé au concours ont été chargés de la conception d'édifices individuels – cf. « Potsdamer Platz - Office » p. 58.

El centro del recinto de Daimler lo constituyen las Arkaden, un pasaje de compras dispuesto entre diferentes edificios. Piano y Kohlbecker crearon el plano maestro del área. A muchos otros arquitectos que participaron en el concurso se les encargaron edificios concretos. Véase "Potsdamer Platz – Office" p. 58.

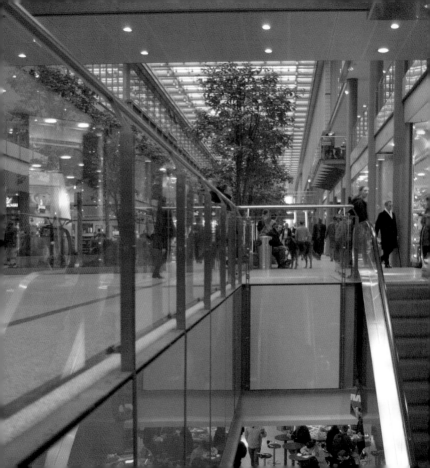

Index Architects / Designers / Structural Engineers (SE)

Index Buildings / Locations

186

Imprint

Published by teNeues Publishing Group

teNeues Book Division
Kaistraße 18
40221 Düsseldorf, Germany
Phone: 0049-(0)211-99 45 97-0
Fax: 0049-(0)211-99 45 97-40
e-mail: books@teneues.de

Press department: arehn@teneues.de
Phone: 0049-(0)2152-916-202

www.teneues.com
ISBN 3-8238-4548-9

teNeues Publishing Company
16 West 22nd Street
New York, N.Y. 10010, USA
Phone: 001-212-627 9090
Fax: 001-212-627 9511

teNeues Publishing UK Ltd.
P.O. Box 402
West Byfleet
KT14 7ZF, UK
Phone: 0044-1932-403 509
Fax: 0044-1932-403 514

teNeues France S.A.R.L.
4, rue de Valence
75005 Paris, France
Phone: 0033-1-55 76 62 05
Fax: 0033-1-55 76 64 19

Bibliographic information published by Die Deutsche Bibliothek
Die Deutsche Bibliothek lists this publication in the Deutsche Nationalbibliografie; detailed bibliographic data is available in the Internet at http://dnb.ddb.de

Edited and texts by Chris van Uffelen
Concept by Martin Nicholas Kunz & Dr. Silvia Kienberger
Art Direction: Michael Knoedgen
Layout & prepress production: Thomas Hausberg

English translation: Maureen Roycroft Sommer
French translation: Françoise Schmidt
Spanish translation: Gemma Correa-Buján

Special thanks to H.O.M.E Das Magazin für die moderne Lebenswelt, www.home-mag.com for their expert advise.

Printed in Italy

While we strive for utmost precision in every detail, we cannot be held responsible for any inaccuracies, neither for any subsequent loss or damage arising.

teNeues

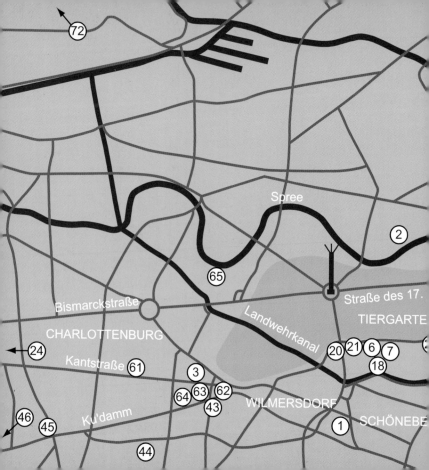

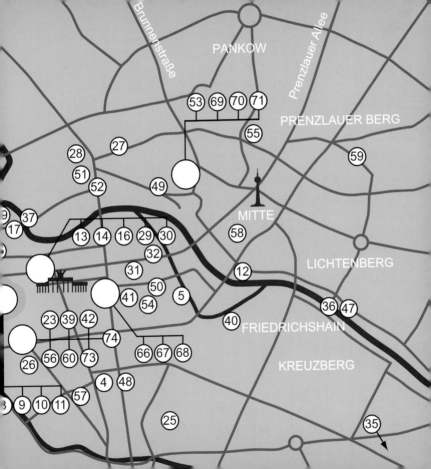

and : guide

To be published in the same series:

Amsterdam	Moscow
Athens	Paris
Barcelona	Rome
Cape Town	San Francisco
Copenhagen	Shanghai
Hong Kong	Singapore
London	Stockholm
Los Angeles	Sydney
Madrid	Tokyo
Milan	Vienna
Miami	

Size: 12,5 x 12,5 cm (CD-sized format)
192 pp., Flexicover
c. 200 color photographs and plans
Text in English, German, French, Spanish

teNeues